BASIC PHOTOGRAPHY

DAVID KILPATRICK

D0817670

HAMLYN

NOTE
Metric and imperial measurements, where both are
applicable, have been calculated separately. Use one set of
measurements only as they are not exact equivalents.

Photography by Mick Duff
Design by Jim Wire

First published in 1984 by
Hamlyn Publishing
Bridge House, London Road
Twickenham, Middlesex

© Copyright Hamlyn Publishing 1984
Third impression 1987

ISBN 0 600 20805 2

Printed in The Canary Islands

Larsa. D. L. TF. 843-1985

CONTENTS

INTRODUCTION

HOW CAMERAS WORK

Light travels in straight lines, and keeps on travelling for an infinite distance unless something blocks its path. These two facts make seeing possible. If light travelled in random curves or faded away gradually, we could not see the stars – or anything else.

The eye sees a picture of the world by directing a small focused image onto the retina at the back of the eyeball. The image is focused by a lens. Simple images can be thrown onto a surface without a lens, using a small hole. If you bore a hole in the door of a totally darkened room, a picture of the scene outside will be projected upside down and left-to-right on the wall opposite the door.

This is the principle of the pinhole camera. It uses simple geometry: straight lines of light from different parts of the outside scene pass through the small hole, and arrive at corresponding spots on the projection surface.

Film

Camera is from the Latin for room. As a curiosity a builder might make a room with no windows in a tower, with small holes to show views of the landscapes around. This was called a camera obscura, or dark room. In Renaissance times it was discovered that convex surfaced optical glass lenses could focus a sharp image with a much bigger hole. Normally a large hole gives a blurred image. The lens bent the light rays to focus them, and a brighter picture was produced. Some camera obscurae used concave mirrors.

The eye uses a lens in the same way. The brain interprets the image, but it cannot store images the way it remembers words. You can use your voice to repeat remembered words, but you have no way to make pictures as you make sounds.

Drawing and painting, demanding skill and never purely objective, is a laborious means by which a few people can re-create images. By the 17th century the artist's camera had been invented. This was a small desk with a lens, and probably a mirror, to shine an image of a scene onto paper. Canaletto is the best-known artist who used a portable 'camera'.

In the late 18th century, scientists, artists and printers experimented to try to 'fix' the image of an artist's camera on paper, without drawing. They found some light-sensitive substances, but did not succeed.

Experiments in the 1820s and 1830s solved the problem, and 20 years later there were several reliable photographic processes being used throughout the world. The difference between a photographic camera and an artist's camera is simple. The film is sensitive to light and responds to both the brightness of light falling on it and the time of exposure.

Photographic cameras have to be fitted with a shutter to keep light off the film; except at the moment of exposure when the 'shutter release' is operated. You cannot examine the image thrown on the film, because any other hole in the camera would let light in and spoil the picture.

The shutter needs a controlled opening time. A timing mechanism opens and closes it. To control the brightness of light reaching the film, the hole or aperture behind the lens can be altered; a large hole gives a brighter image, a small hole a dim one.

In the artist's camera, you could see the image all the time, and a mirror turned it the right way up. Subjects at different distances need adjustment in the lens-to-film distance to ensure sharp pictures. This is easily done when you can see the image, but a photographic camera needs a focusing distance scale or system. Having an upside-down picture inside the camera doesn't matter because the picture is turned the right way up later.

To aim, frame and focus the picture a camera needs a viewfinder, because you cannot examine the image on the film. Some viewfinders use light from the main lens to form a viewing image; others have a separate set of lenses.

The film has to be contained in lightproof cartridges, cassettes or rolls. They allow you to load the camera in daylight. After the camera is closed, and all light sealed off, the film is wound into place.

This is the basic design of all cameras: a lens which forms an image, a viewfinder to aim the camera, film to receive the image, and settings for distance (focus), image brightness (aperture) and exposure time (shutter). The diagram shows how an image is formed by a camera lens.

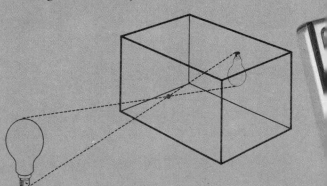

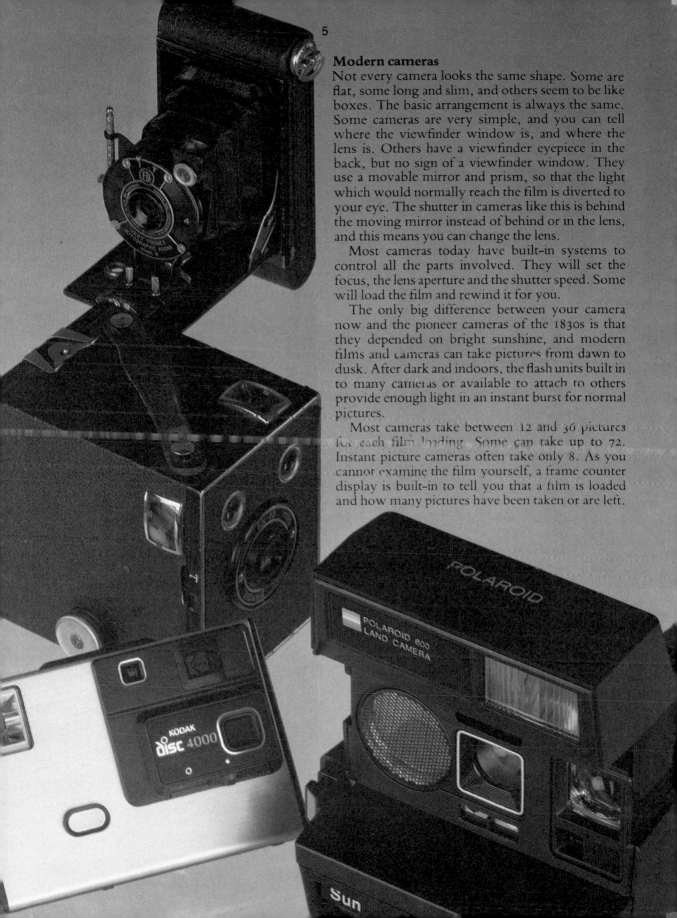

Modern cameras

Not every camera looks the same shape. Some are flat, some long and slim, and others seem to be like boxes. The basic arrangement is always the same. Some cameras are very simple, and you can tell where the viewfinder window is, and where the lens is. Others have a viewfinder eyepiece in the back, but no sign of a viewfinder window. They use a movable mirror and prism, so that the light which would normally reach the film is diverted to your eye. The shutter in cameras like this is behind the moving mirror instead of behind or in the lens, and this means you can change the lens.

Most cameras today have built-in systems to control all the parts involved. They will set the focus, the lens aperture and the shutter speed. Some will load the film and rewind it for you.

The only big difference between your camera now and the pioneer cameras of the 1830s is that they depended on bright sunshine, and modern films and cameras can take pictures from dawn to dusk. After dark and indoors, the flash units built in to many cameras or available to attach to others provide enough light in an instant burst for normal pictures.

Most cameras take between 12 and 36 pictures for each film loading. Some can take up to 72. Instant picture cameras often take only 8. As you cannot examine the film yourself, a frame counter display is built-in to tell you that a film is loaded and how many pictures have been taken or are left.

HOW FILM WORKS

All films are manufactured to be sensitive to light. Films do not need battery power, chemicals or anything else to make them light-sensitive.

Before and after the film has been used, it is equally light-sensitive. If you expose film to even the slightest light, it will be spoiled. In full sunlight it only takes 1/100,000th of a second to wipe out normal film completely.

Film is packed in lightproof cassettes, cartridges, disc packs or rolls. Though loading methods vary, in most cameras you place the film inside, close the back, wind off any 'blank' frames, and are then ready to take pictures.

Only 35mm cameras have film which needs to be rewound. With all other cameras, you remove the film after use without rewinding.

The image formed by light on film is called a *latent* image, because it lies in the film invisibly, and has to be brought out by developing with chemicals. The latent image is totally invisible. Development is even needed in instant pictures, but the chemicals are held in the print material and released to go to work as soon as the shot has been taken.

Regardless of the size and type, all films work in the same way and have similar basic structures. Their light-sensitivity is measured on the same scale (ISO).

Intermediate stages

Sometimes you can have a picture which can be viewed but is not the final stage. As soon as an instant print is ejected from a camera, it starts to develop. You can watch the image come up, gradually, in daylight. It is not completely formed until 10 minutes is up, but you can tell after a minute whether or not the shot will be any good.

With other films, you don't see this stage, because they are sent away and developed in total darkness, in machines. Instead, you receive your prints along with a strip of negatives. This is a fully developed film, no longer light-sensitive, but it is an intermediate stage.

In a negative, all the tones of the original scene are reversed. Black is shown as clear, blank film; white is shown as solid black film. Colours are also reversed – a blue sky is recorded as yellow, green grass as red, a yellow dress as blue, red lips as green. The strip of negatives has an overall orange colour, to match it up to the kind of paper used to print on. The orange colour may mask the real 'negative colours' but they are still there.

Slides are made with film which is developed to its true tones and colours for direct viewing. It is

called 'reversal' or 'positive' film. Though slides usually come back mounted for viewing, the film is processed to form a strip of frames just like negatives. Reversal or positive film does not have to be printed, just cut up and mounted in plastic or card frames.

A choice of results

The film you buy determines the result you get. You cannot buy a slide film, then take it into a shop and ask for it to be developed as negatives. You cannot buy black and white films and ask for colour prints.

With negatives, in colour or black and white, you do have a choice. You can send the film to a very low-cost service for small prints, and expect reasonable results, or pick a more expensive service with larger prints and expect excellent prints.

Slides come back mounted for projection, or for viewing in an illuminated table-top viewer. They can be handled by the broad margins of the mount. Unlike negatives, slides are not connected together, so a single one which you do not like can be thrown away. They can be printed after you view them; the slide must be sent away, as there is no negative, but prints are just as easy to get.

Inside film

All photographic films use an *emulsion* made of soft gelatin or plastic material, impregnated with chemical crystals. The crystals are special compounds of silver which are light-sensitive and treated with dyes and additives to make them respond to particular colours.

Colour films are made up of 3 or 4 different emulsions, sensitive to different colours, and barrier layers of coloured gelatin between. Instant prints have extra layers which hold reservoirs of chemicals, soak up waste products and produce the white backing so the print can be viewed.

When light hits the film, it is absorbed by the emulsion layers and alters the silver compounds invisibly, forming a microscopic 'seed' of metallic silver. At the back of the film, a deep black layer stops the light being reflected back again.

The gelatin emulsion lets developing solutions soak through and surround the silver salts when the film is processed. The developer selects only the crystals with seeds of silver and precipitates more silver in them. The image starts off faint and, as the silver is formed, gets darker. For positive images, a later stage reverses the tones so that those parts which received most light end up lightest. Finally, other chemicals are used to make the film clear, neutralize remaining crystals and wash out all the residues. In instant prints these are stored in a hidden layer at the back of the image.

BASIC CAMERA TYPES

The quality of a picture depends mainly on the size of the film image, whether it is a negative or a positive (print or slide). Small prints look sharp even from small negatives, but if all or part of the picture is enlarged it can become grainy and indistinct. Small prints from larger negatives look better and larger prints stay sharp.

Large film sizes need large cameras, which are expensive to buy and cumbersome to carry and use. All the accessories have to be in proportion. Each shot is also more expensive. Small cameras need small film sizes. By clever design they can be made very flat, slim or folding. The first decision to be made when buying a camera is whether to choose one that is ultra-compact, compact, fairly large or definitely big.

Camera use is limited by factors like dim light, fast-moving subjects and being too close or too far away from the subject. These problems can be overcome by lenses which gather more light, shutters which open and close rapidly to freeze action, and lenses which cover wide angles or magnify like telescopes.

These features are difficult to include in very small cameras, as they need precision. They are easier to add to medium-sized models. They are included in some large cameras, but bulk and cost are high.

The different sizes of camera are called different *formats*. This word is also used to describe the film or picture shape and size. The size of the camera can also be described by the type of film it uses, which may be a name or a number.

Disc cameras take film discs. There is no code number for this film size. The film has 15 exposures, with each negative measuring 8 × 10mm, on a circular sheet of film held in a flat plastic cartridge. In the centre of the disc there is a magnetic computer track which is used after the film is processed to balance the colour and tell the printing machines how many pictures to make. Disc film cameras are slim and pocketable and use the smallest film size. It is suitable for prints up to 15 × 20cm/5 × 7in.

Pocket cameras take miniature roll film cartridges. The film is called size 110, and the cameras are also called pocket instamatics or 110 cameras. Each cartridge has 12 or 24 exposures, 11 × 17mm. They can be colour or black and white negatives, or slides. Some 110 cameras have all the features needed to extend photography – 'fast' light-gathering lenses, which can be zoom or interchangeable for wide-angle and telephoto shots, accurate focusing and action-stopping shutter speeds. But the small negatives mean that the biggest good prints are 20 × 25cm/8 × 10in. Most 110 cameras are long and slim but fairly thick. They are light and pocketable, and often very inexpensive.

Instamatic cameras are not instant-picture models despite the name. They take a roll film 35mm wide in plastic cartridges, for 12 or 24 square pictures. The film is called size 126. Most 126 cameras are low in cost though at one time a few makers produced high-quality models. The biggest normal print size is 20 × 20cm/8 × 8in. Sharpness is limited by cheap lenses but the film is capable of much bigger prints from 28 × 28mm negatives.

Compact 35mm cameras take the same width of film, but instead of being in lightproof plastic cartridges the film comes in small metal cassettes. The picture is oblong instead of square, and negatives or slides are 24 × 36mm. Unless the camera has automatic film loading, the end of the film must be clipped to a spool and positioned carefully before closing the camera. The optical quality of good

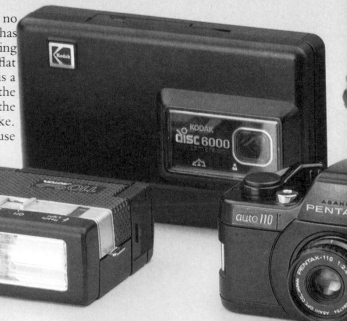

35mm 'compacts' can be excellent; pictures may be enlarged to 50 × 80cm/20 × 30in. Many types have collapsible or folding lenses, with sliding covers so no case is needed, and can be slipped into a pocket or handbag. Some are simple, with nothing to set; others have all the settings, but work fully automatically; a few have manual adjustments which call for understanding cameras. The lenses are usually slightly wide-angle. Compact 35mms are ideal alternatives to disc or 110 cameras for family, holiday and general pictures where extra picture quality is appreciated. Film cassettes are available in 12, 24 or 36 shots and the widest possible range of films is available.

35mm SLRs (single-lens reflexes) take the same film size but are larger, because they have a superior viewfinder system which allows lenses to be changed. Very close subjects, panoramic scenes and small or distant details can be photographed. Fast action can be stopped and pictures taken from noon to twilight or after dark with a tripod. No cameras have a greater range of accessories. Types range from fully automatic to fully manually controlled at all price levels. The 35mm SLR normally starts off a system, with 1 or 2 extra lenses, a flash and other accessories acquired as interest grows.

Medium-format cameras are also called rollfilm or 120, which is the film size they use. This film comes on spools with a lightproof paper backing. The image format ranges from 6 × 4.5cm/2¼ × 1¾in to 6 × 6cm/2¼ × 2¼in, 6 × 7cm/2¼ × 3in or 6 × 9cm/2¼ × 3½in. The number of pictures per roll depends on the format and whether 120 (single-length) or 220 (double-length) films can be used. The minimum is 8 and the maximum 32 but 10, 12 or 15 are normal. Prints up to 1.2 × 1.65m/4 × 5 ft can be made without losing quality. All necessary lenses and accessories are produced in limited ranges, but the cost of rollfilm cameras is high. They are intended for professional use.

Large-format cameras take sheets of film, a single shot at a time, and have to be used on a tripod. They are for the highest quality professional work but most colleges use them for teaching photography as the workings and effects of decisions can be seen clearly. Film sizes range from 9 × 12cm/3½ × 5in to 20 × 25cm/8 × 10in.

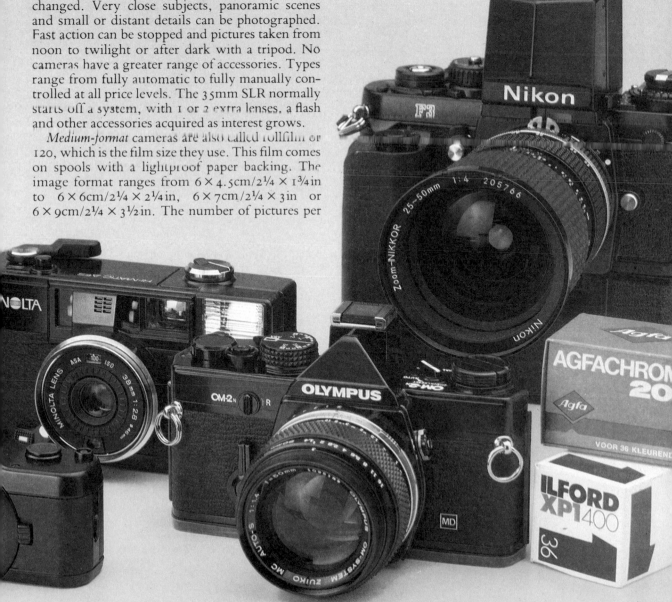

CHOOSING FILM

Some cameras are designed to take one type of film only. If you buy an instant print camera, you must use the maker's specified film, so most of the details given here do not apply. Instant prints are ideal for family shots, party shots and indoor flash. Most cameras take a range of different films.

There are 3 basic sorts of film (excluding instant prints). Black and white film for prints is only able to give black and white results, and processing is more expensive than for colour. Colour negative film for prints allows you to order extra copies at low cost for friends and family. Colour transparency or slide film needs a projector and screen to be seen at its best.

Slides can be made from colour negatives, and prints made from colour slides, but both cost more than direct slides or prints. Colour prints and slides can be converted to black and white, but not the other way round.

Most people want colour prints, because no equipment is needed to view them. Disc and 110 cameras are intended for colour prints. Colour negative film tolerates mistakes in exposure or lighting which can be compensated for when the print is made.

Slide film cannot be corrected so any mistakes show up. It is harder to use. Disc and 110 cameras are not normally suitable for slides. Black and white is the best choice if you want to learn about home processing and make your own prints.

Film speed
Some cameras are better equipped to deal with dim light than others, and some have much sharper lenses for recording fine detail. Any camera which takes a choice of film types can be used in lower than normal light by loading a more sensitive film. The detail in a picture can be improved by using a film with better sharpness and finer grain.

Naturally, a camera already able to work in low light will have its range extended even further than a snapshot model when a 'fast' or sensitive film is used, and one with a very good lens will benefit more from a 'slow' or fine-grained film.

The sensitivity of the film is called its speed. The higher the speed, the lower the sharpness and the coarser the grain-structure which forms the colours or tones. Film speed is written as a number; low numbers mean slow film, high numbers fast. The normal scale is the ISO rating which has 2 numbers separated by an oblique stroke. You only need to look at the first one, because this is the number which has to be set on your camera if it has a film-speed dial.

A slow film might be ISO 25/15°. A normal (medium-speed) colour print film is ISO 100/21°. A fast film for winter or dull-day shots is ISO 400/27°. A very fast film is ISO 1000/31°. The figure you set on the camera scale is 25, 100, 400 or 1000 respectively.

If you have a simple non-adjustable camera there is nothing to set. Buy medium-speed (100) film for sunny days and fast (400) for dull days. If you own a disc or 110 camera the cartridge is notched so that the film speed is programmed automatically when you change the film.

35mm and rollfilm cameras with built-in meters must be set to the correct film speed before use. Some have a slot where the torn-off cardboard box end from each new film can be put, to make sure you remember which film is loaded. When the camera is closed there is no other way of telling. If you set the wrong film speed, results will be bad. Setting a fast film speed (400) when there is a medium-speed film loaded means all the pictures will be too dark. Making the opposite mistake does not matter as much if the film is for prints, but slides will be spoiled (too light).

Which film?
Film speed affects how you use flash, whether you can freeze action, and whether you need a tripod. With a fast film, the flash gives good results at a greater distance. Using ISO 400 film instead of ISO 100 means being able to take flash pictures up to 10m/30ft away instead of up to 5m/15ft away with a simple camera.

When the camera has a full range of settings, the faster film lets you use shorter (fast) shutter speeds which stop action (p. 14). It may also let you use a hand-held camera in dim light, when slower film would need an exposure too long to keep steady by hand.

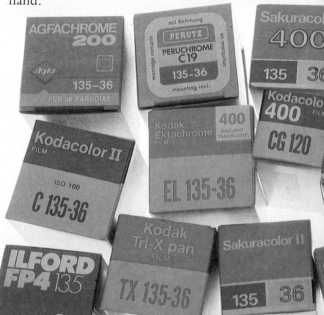

Grain and sharpness

Extra light-sensitivity is gained in film at the expense of sharpness and grain. A large print from a fast film reveals a pattern of small irregular dots making up the image. This is the grain; all films have it, but on small prints you can hardly see it.

Small negatives like disc and 110 format naturally show the grain more on prints, because they have to be enlarged more. Large rollfilm negatives may not produce any visible grain in a print.

Medium-speed ISO 100 film (whether colour print or slide, or black and white) is balanced so that the grain is never very coarse unless you blow up the picture bigger than the sizes mentioned in the last section (pp. 8–9). To make very detailed small prints, or acceptable large ones, a slow film is needed.

Slow films are the reverse of fast ones. They need good light to stop action, and may need a tripod even in daylight. Colours are brighter, grain finer, detail better. You can buy slow films for 35mm, 110 and rollfilm cameras but not for disc cameras. There are no slow films for colour prints, only for slides and black and white.

Your most likely choice is between medium-speed, for everyday use and all summertime pictures, and fast film for winter, indoor and evening shots. There is no choice in instant print films but Polaroid 600 film is more sensitive than others.

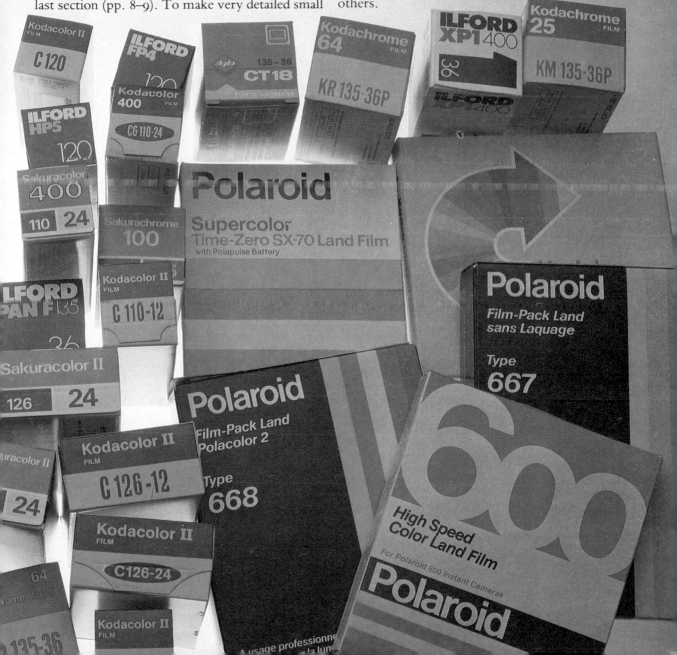

UNDERSTANDING YOUR CAMERA

THE SHUTTER AND APERTURE

Adjustable and automatic exposure cameras have two controls which make sure the film receives the correct exposure. The shutter lets light reach the film for an instantaneous fraction of a second, and makes the exposure. When flash is used, it fires during the shutter opening time. The lens aperture is a variable hole or a set of different-sized holes, in or behind the lens. As the aperture is made smaller, the brightness of the image formed on the film by the lens is reduced.

The two controls are used in combination. In simple cameras, one may be fixed and the other variable. The shutter alters the exposure by changing opening time. The longest time that a shutter can open for, and give sharp results when the camera is held by hand, is 1/30th of a second. The shortest time which can be controlled without a very expensive mechanism is 1/500th of a second on simpler cameras, or 1/1000th of a second on 35mm SLRs. 'Normal' shutter speeds (as the opening time is called) are 1/60, 1/125 and 1/250.

Shutter types
The object of the shutter is to keep light off the film, except during the instant of exposure. In most cameras, the shutter is inside or just behind the lens. The shutter is either a simple metal leaf which moves aside or a set of precision leaves timed like a watch. Some operate mechanically and others are electronically timed. Simple cameras have a simple shutter, with one or two speeds only.

If the shutter is inside or behind the lens, a separate viewfinder has to be fitted to the camera as it would be impossible to see through the lens. The lens cannot be changed or removed, because the shutter would also be removed and the film would be spoiled.

Interchangeable lens cameras have a shutter called a 'focal plane' shutter, just in front of the film. This is more expensive because it has to be bigger. It can be made of rubberized cloth or metal louvres. A mirror may be positioned between the shutter and the camera lens to divert the image into a viewfinder system. When the shutter is pressed, the mirror flips upwards before the shutter opens and drops down again as soon as the exposure is finished.

Automatic exposure cameras do not normally indicate which shutter speed is in use. If they do, a scale will appear in the viewfinder. Because the picture is likely to be blurred if an opening time longer than 1/30th of a second is used, most cameras have a warning light or signal telling you to use flash or a tripod as soon as the autoset shutter speed falls below 1/30.

Fully adjustable cameras normally have a shutter speed dial or scale marked from 1 second to 1/1000, but some have a limited range like 1/8th of a second to 1/250. Speeds longer than 1/30 are normally in

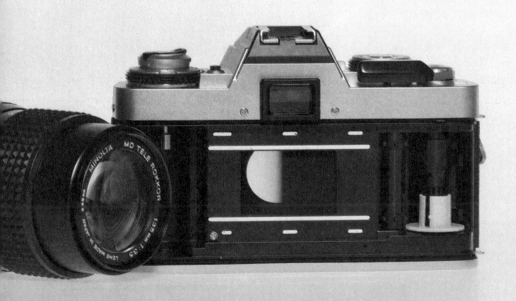

red to warn against hand-held use. This shutter speed range can *only* be used if the aperture is adjusted (manually or automatically) to keep the exposure the same when a new shutter speed is selected.

In the picture, you can see the focal plane shutter of a 35mm SLR camera. It has been photographed specially so that its action is frozen halfway across the film frame area. Normally it moves across so fast that the eye cannot see it.

Lens apertures

It is easy to understand the shutter speed scale when you first use it. Anyone will realize that 1 second is a long opening time and 1/1000 is so short that it will stop fast action or cut down very bright light.

Lens apertures are not as easy to understand. On simple cameras they are sometimes fitted, but instead of being marked with numbers they are identified by weather symbols – sun, hazy sun, cloud, black cloud and cloud with rain.

On better cameras there is a scale. Do not confuse it with the focusing scale if the camera has adjustable distance focusing. The focusing scale will be marked 'm' or 'ft' and one end of it has a symbol for infinity (a reclining figure 8). The lens aperture scale probably has no identification other than a set of evenly spaced numbers; it is normally at the back of the lens, next to the main camera body. The series of numbers runs 1.4, 2, 2.8, 4, 5.6, 8, 11, 16, 22, 32 but not all lenses have the whole series. Most have a scale covering seven steps: 2, 2.8, 4, 5.6, 8, 11 and 16. The smallest number may be an odd one like 3.5, 4.5 or 1.7.

This is the widest aperture of the lens, with no reducing aperture 'stop' to cut down light. Small aperture numbers admit more light; increase the aperture number and the light is reduced. Each aperture step or 'f-stop' halves the light reaching the film. Thus f8 lets in half the light of f5.6. You would use f11 on a bright day, f4 on a dull day. You can tell if a camera will be suitable for dim light by looking at its lens; normally, the maximum aperture is written near it. An f2 lens (sometimes written 1:2) is better for low light than an f5.6 (1:5.6).

Remembering the controls

If you own an automatic camera which sets both controls, there is nothing to worry about apart from the film speed. Adjustable cameras with either shutter or aperture controls *must* be set correctly before each picture.

The scales are easy to use once you remember that big numbers are for 'big' light. The brighter the light, the bigger the number you will need on either the shutter scale, the aperture scale, or both. When there is little light, you need little numbers.

Big numbers also give 'more' in the picture. More of the shot will be sharply focused with large aperture numbers; faster moving subjects will stay sharp with bigger shutter speed numbers. These are both reasons why it is easy to take better pictures on bright, sunny days.

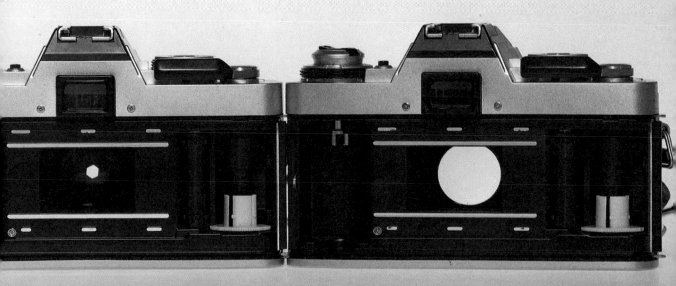

LIGHT AND EXPOSURE

Exposure is a combination of the brightness of the scene you photograph, the film speed, and the shutter and aperture controls. The film speed is the fixed factor. The light level, or brightness of the scene, is the variable one.

To match the two, the shutter speed and aperture have to be correctly set. You can do this by looking at the simple exposure tables supplied with films. They work because clear sunshine is always roughly the same in brightness, and the tables cover simple weather conditions which are easily recognized.

Press photographers have a quick way of setting approximate exposure. The shutter is set to the same (or close) figure as the film speed. For ISO 100 film, set 125 (1/125th of a second) on the shutter. For ISO 400 film, set 500 (1/500th of a second).

Once this is done, use a table which is easy to remember:

Bright sun on sand or snow	f22
Bright sun, normal subject	f16
Hazy sun	f11
Cloudy but bright	f8
Cloudy, overcast	f5.6
Cloudy and dull	f4
Heavy dark cloud	f2.8

Within 2 hours of sunrise or sunset, use a setting for two steps lower light. In winter, always use the next lower step.

Exposure steps

The table is divided into even steps. In fact, each step lower is half the light level of the one above. Each aperture stop admits twice the light of the one above.

The shutter works the same way. Each speed step is a halving or doubling of the adjacent ones. 1/125 lets in half the light of 1/60, and twice as much as 1/250.

You can use the shutter and aperture scales to balance each other. If you adjust the aperture to let in half as much light (the next bigger number) then changing the shutter to admit twice as much light (the next smaller number) keeps the exposure constant.

Bright sunlight with ISO 100 film needs an exposure of 1/125 at f16. This could equally well be:

1/60	f22
1/250	f11
1/500	f8

The exposure the film receives from all these combinations is identical. The reason for choosing one

particular pair of settings will be discussed later (pp. 38–41). For the time being, it should be clear enough that 1/500 at f8 is a brief (fast) shutter speed at a medium aperture setting, but 1/60 at f22 is a longer exposure at a 'stopped-down' setting. This is a term you may hear. Stopping a lens down means closing its aperture to a larger f-number.

Automatic exposure

Automatic exposure is only given by cameras with a built-in exposure meter. A camera with no settings to adjust does not make it an automatic. It may be fixed at 1/125 and f11, an average exposure which gives acceptable results in sunshine or thin cloud.

Some automatic cameras set both the shutter and aperture. You may not have any idea of the actual settings unless the camera warns that you should fit or use flash. Some set one control, after you have set the other. If the aperture is manually set, the camera will select a shutter speed to suit the light and vice-versa. Cameras like this normally have a viewfinder read-out which shows the setting being selected by the camera, as this is the only basis for deciding what manual setting to make first.

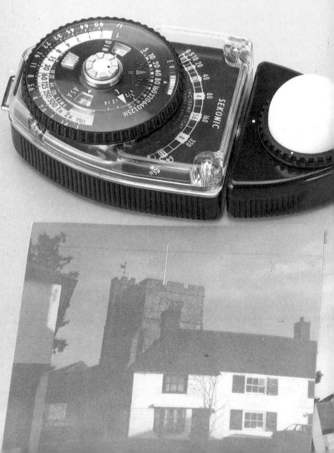

With this kind of camera you are really choosing both the shutter speed and aperture, but if the light changes slightly the camera will compensate with small adjustments. For a big change in light, you will probably adjust the 'priority' setting (the one you set yourself) as well.

Exposure metering

Other cameras either have built-in coupled exposure meters, without automatic control, or need a separate hand-held exposure meter with readings transferred by the photographer to the camera settings.

Most coupled meters have a needle or lights which you centre up by adjusting the controls. When the needle lines up with an index, the meter shows correct exposure; when the light in the finder turns from red to green, the settings are right. You still set one control first, and then adjust the other until the reading is correct.

Separate meters usually have a scale with numbers from 1 to 20 (or thereabouts). A calculator dial is set for the film speed, then the meter is aimed at the scene to be photographed. The needle indicates a number, say 15. You turn the calculator dial to 15. Then you look at the two scales which run against each other, one for shutter speeds and one for aperture numbers.

The meter shows all the possible combinations. If f11 is against 1/125 (11 next to 125, because the numbers are written in the shortest form), f16 is against 1/60 and f8 against 1/250, and so on. Look at the scale and pick the right combination. Then set the camera controls to match this.

What do you meter?

With any normal camera or light meter you aim at the area you want to photograph. If the light changes take another reading. Do not make the mistake of letting a hand-held meter aim upwards, even slightly, or it may read from the sky, which is much too bright. Exposure meters are not needed for flash pictures.

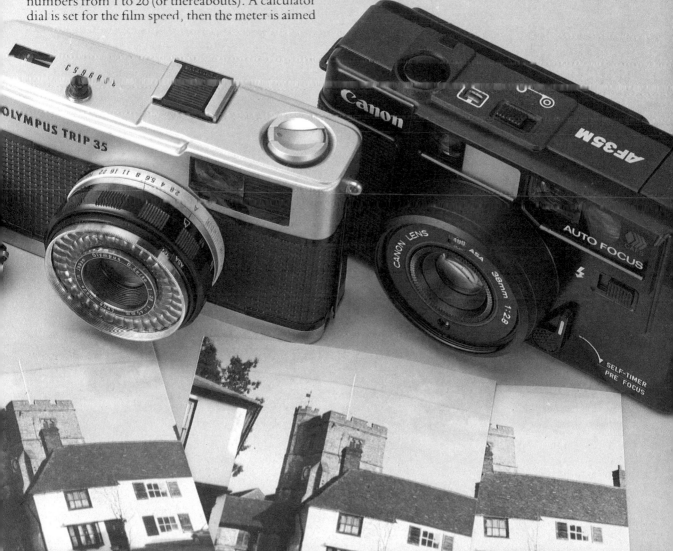

LENSES AND FOCUSING

Camera lenses form an image on the film, using light from the subject photographed. If the film is the wrong distance from the lens, the image is not sharp. The principle is the same as a magnifying glass making a bright pinpoint of light from the sun to burn paper; if the lens is at the wrong distance, the pinpoint becomes a blur and the paper does not burn.

A distant subject, like the sun, is focused when the lens is closest to the film. As there can be nothing further away than infinity (any subject over 30m/100ft away in practice) the lens never needs to move closer. To focus close subjects, the lens has to move away from the film. Changing the focus from infinity to 1m/3ft may only need a tiny adjustment to the lens movement.

If lenses were very critical, then the region of sharp focus would be shallow. You might focus on a person's eyes, and their nose would be totally blurred. With ordinary cameras, this does not happen. There is enough 'depth of field' (or subject focus depth) to cover normal subjects. Eyes, nose, ears and most of the background will look acceptably sharp.

Depth of field depends on the film format and the lens aperture. Small film sizes like disc and 110 may not need any focusing adjustment, because everything from 1.5m/5ft to infinity is sharp enough for small prints. Some 35mm cameras may have 'fixed focus' too. Most have focusing, as do all larger cameras.

Stopped-down (large number) apertures, which create a small central hole in the lens, increase depth of field. Some cameras have a small scale, which shows the distance range in sharp focus at any given aperture. Wide open (small number) apertures give shallow depth of field. It is possible to have the eyes sharp but the nose and ears blurred with 35mm and larger cameras if you deliberately pick an aperture like f2.8 or f1.7.

Like the shutter and aperture scales, the focusing scale of most cameras has to be set before each picture unless you are shooting general landscapes and can leave it set to infinity. The closest focus depends on the camera; nearly all focus to 1.2m/4ft and most to 80cm–1m/2ft 6in–3ft. For closer focusing, 35mm SLRs and some instant cameras can be used without accessories at 45cm/18in.

Focusing scales

Cameras which need accurate focusing have detailed scales. Those with more natural tolerance have simple scales. The simplest are symbol focus settings: portrait, full-length figure, group and landscape. The symbols may have click-stops so that the focusing ring, when turned, naturally stops at each setting.

On cameras with built-in flash the focusing ring also sets the flash exposure. If you forget to focus, the picture will be wrongly exposed as well as blurred, so it is doubly important to remember it even if it only uses symbols.

Scale focusing is marked in convenient distances in either metres or feet, or both. There may be click-stops for suggested 'universal' focusing distances – 3m/10ft is an example. A camera set to this, in bright sun, gives sharp pictures from around 1.5m/5ft to infinity.

Some cameras have no focus control that you can see because they use automatic focusing. As the

shutter is pressed, a sensor judges the distance of whatever is in the middle of the picture and sets the lens. If the subject is not in the middle of the picture, the focus may be wrong. A mark in the viewfinder helps you line up the subject to be focused. To change the composition, the setting can be held by half-pressing the shutter, re-aiming the camera, and then completing the pressure.

Focusing aids

Judging distance is a problem for most people, so all but the simplest cameras have some kind of focusing aid. This may be a spot in the viewfinder which creates a double image when the focus is wrong, but merges to form a perfectly sharp image at the point of focus. Other focusing aids make the image appear to shimmer when out of focus, or move part of it out of alignment. When using cameras with viewfinder focusing you do not need to look at the scale on the lens. You simply turn the focus ring until the viewfinder indicates sharp focus and take the picture.

For people with poor eyesight, the focus aid may be electronic. The image sharpness is measured in the camera and a green light comes on when the picture is correctly focused. This allows you to take good pictures even if you find the viewfinder indistinct and can only see vague shapes.

SLR viewing

Single-lens reflexes have focusing as well as viewing through the lens. Inside the camera, a mirror diverts the lens image onto an etched screen the same size as the film. Through an optical prism and lens, you see the image just as it will be recorded when the shutter is pressed. If the image is out of focus, it looks blurred. Turn the focus ring on the lens until the best sharpness is produced. Most SLR viewfinders have a central focusing aid and may also include electronic focusing or autofocus.

Focusing, unlike exposure which produces light or dark results when wrong, is subjective. A picture which an experienced photographer considers too blurred to keep may be acceptable to a beginner. A correctly focused picture should be at least as sharp as the same subject seen by eye, and if your distant vision is bad, a photograph may appear sharper.

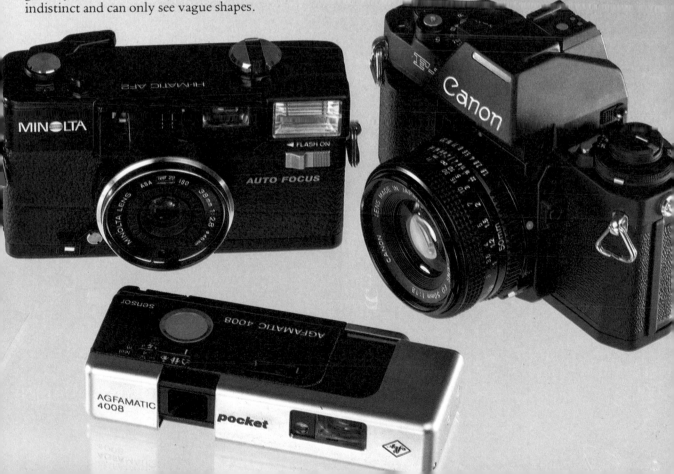

THE VIEWFINDER

When you lift a camera to your eye, there should only be one window visible on the back. With some pocket cameras, the back looks very similar to the front and it is not entirely clear which side houses the lens.

To use a viewfinder correctly, your eye must be positioned as close as possible to the viewing window. It also helps to get it dead centre. Most finders have enough leeway for spectacle wearers but you may have to press the camera against your glasses.

Through any modern viewfinder you see a clear, sharp-edged outline of the picture frame. This may be the edge of the finder, in which case it will be particularly clearly defined. If there are scales or signals visible, they are right next to the edge of the picture. Some viewfinders show a little more than the picture will include, with a silver reflected outline of the frame superimposed.

If the edge of the field of vision looks fuzzy, or there is no superimposed rectangle, your eye is probably too far from the eyepiece. Because you are only seeing part of the picture, you will probably stand too far away. When you see the prints you will wonder why things do not seem as close as they were. Some viewfinders have small central rectangles, bullseye circles or marks. These do not have anything to do with the picture area. If you confuse them with the frame outline your subjects will look very small indeed on the prints.

The photograph shows a camera with a special viewfinder which allows people with spectacles to view it from a few centimetres away and still see all the frame.

Different finders

A disc or pocket camera may just have an optical window, with no marks. The subject is seen at a reduced scale, which helps you to compose it easily. A better simple camera will have a larger, clearer finder with a superimposed frame to outline the view. At the top and left-hand edges there may be an extra set of double lines. These are called parallax marks or close-focus framing guides. You use them when you are closer than 2m/7ft, to compensate for the different positions of the viewfinder and the lens itself. By making sure the subject does not cross the inner set of lines or marks, you avoid cut-off heads.

With most cameras, the picture is oblong rather than square. If you think about the shape of the subject first, many of your pictures may be better off with a vertical composition. The camera is turned on its side, but the viewfinder is used just the same way. Remember not to do this with some instant picture cameras, or the border round the picture may look uneven because there will be a broad margin to one side instead of underneath.

Autofocus and rangefinder cameras have a central spot in an optical window finder. For autofocus, this spot is just a silvered patch or outline to line up with the part of the scene you want to focus on. Rangefinder cameras have a similar patch, with a double image visible until you focus correctly.

The viewfinder of an SLR camera looks different, because instead of 'seeing through' a window, you look 'at' a screen. The focusing screen has a finely ground texture and may have concentric lines on it. If you are not able to see the screen texture sharply, you should ask your optician for a spectacle prescription and obtain a viewfinder eyepiece lens to match this. Most makers supply a range of these.

In the centre of the viewfinder there will be a 'bullseye'. The outside disc of this is normally fine-ground glass, for focusing on detail. Then there is a circle of 'microprisms' which are brighter and appear to shimmer when the image is out of focus but disappear entirely when focused. In the middle, a small split-image rangefinder focusing device is normally added. Some SLRs have just one focusing device, or none. Most have the three mentioned in combination because at least one of these will suit the user, even if the others do not.

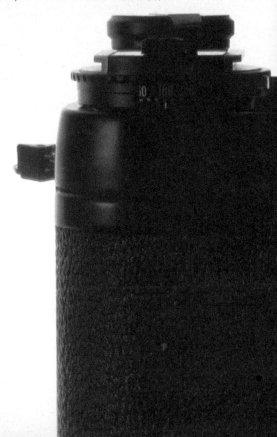

Centering your eye on an SLR finder eyepiece is important. If you look through off-centre, the focusing aids may seem to go dark or black out completely. You may not see all the frame. Remember to hold the camera in contact with your eye or forehead and cheek.

Displays and data

Most cameras have information displayed in the viewfinder so that you can adjust settings, or see what the camera's automatic exposure is doing, without taking the camera away from the eye.

Normally these are at the edges, top or bottom of the frame. Sometimes they form part of the super-imposed silver frame. There are needles moving against scales, lights or 'LEDs' (Light Emitting Diodes), liquid crystal scales, and optical systems to view scales on lenses. Apart from LEDs, which glow, all need adequate day or room light to be seen clearly.

The most common display is a flash or camera shake warning light on automatic cameras. When symbol focusing is used, the symbols may be repeated in the viewfinder with a moving needle. Cameras with auto exposure may have a shutter or aperture scale and needle.

Other displays include a window which views the aperture set on an SLR lens, displays the shutter speed and shows whether or not the camera is being used on 'auto' or 'manual', and a light in the finder which comes on when a flashgun is ready for use.

Because all cameras are different, refer to the instructions to learn about displays. Always remember that if something is mentioned you should be able to see it; if you cannot you are probably not using the camera correctly.

BASIC COMPOSITION

Picture composition is important. Cameras take care of most technicalities, and the biggest difference between pictures is what they show and how well they are composed.

Bad composition starts in the viewfinder, for some of the reasons already outlined. The two main simple faults in beginners' pictures are tilted horizons or leaning buildings, and subjects shown far too small in the centre of an empty frame.

Fault finding

If your pictures come back with the horizons consistently tilted one way, you may be holding the camera rather awkwardly with one hand higher than the other. To correct the fault, always look at the horizon and the top frame of the finder, and try to keep them parallel. People who do not see the frame properly often have tilted or leaning pictures.

Subjects which are too small happen for two reasons. The first one is that the central focusing aid tends to concentrate attention, so that you see all the frame but ignore the outer edges, thinking your subject is clear enough if the circles or marks in the centre cover it. To overcome this, try to ignore the centre of the finder and think of the whole frame as a print.

The second reason is that despite an ability to view and compose properly, the photographer's eye position means that only the middle of the finder is visible. Correct eye positioning is important.

The eye has an ability to concentrate, which the camera lacks. This means that even if the subject is a very small part of a scene you focus on it and ignore the rest. The brain also has a balance mechanism in the ears which overrides the eye. Even if you tilt a camera badly, you do not see the horizon tilt; it stays level and the finder frame tilts. The eye ignores this because the brain knows you are standing normally and the horizon is straight.

Finally, a word or two about those cut-off heads and feet. Clear, bright viewfinders mean fewer heads are cut off today than was once the case, but if you take a group, you may still cut off their feet and leave half the print as blank sky. This is because you tend to aim the middle of the viewfinder at the faces to focus. Remember to re-compose the shot, including feet and omitting clouds!

Cut-off heads happen at close distances with viewfinder cameras if you ignore the close-up framing marks in the finder. They happen with simple cameras because there are no framing marks to start with. Never go closer to the subject than the instructions for the camera allow; with simple cameras, stay 1.5m/5ft away.

If you can overcome these faults and include all the subject, filling most of the picture with nothing important cut off, and keep the camera level, then half the battle is won. You are a better photographer than at least half your neighbours!

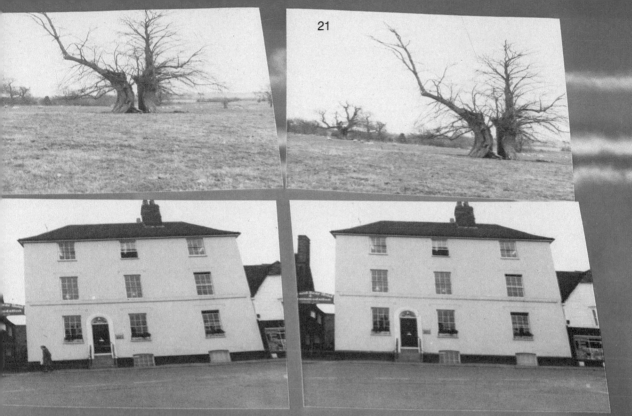

Good composition

Look at the pictures on the left hand side of each pair. Then compare them with the same shots on the right-hand side. There is a big difference.

First of all, approach your subject at the right distance. A portrait is best taken from around 1.2–1.5m/4–5ft with most cameras. A shot of a building should have no more than 20% spare sky and ground around it, to provide some framing. Action pictures, when you cannot get close, should include an interesting background even if the subject is fairly small.

That central focusing spot is compulsive! It is tempting to put the centre of interest in the centre of the picture. In fact, that is not the strongest point. Artists know that the real visual centres of interest are about one-third of the way in from the edges. Imagine a vertical line and a horizontal one, each drawn one-third of the way in across the frame. Where they cross, there is a very strong focal point.

To compose a shot well, place a face (or the eyes on a portrait) on a 'rule of thirds' point. Make the horizon divide the picture into two-thirds ground, one-third sky. If there is a strong vertical element, like someone standing in front of a scene on holiday, place them on a vertical 'one-third' line, looking 'in' to the main two-thirds of the picture. This is a very simple and rigid way of approaching viewfinder composition but it does make better pictures.

Now look at the straight lines in your subject through the finder. The most important is the horizon, or where the horizon would be. In a seascape, it is a perfectly flat straight line. You have to keep seascape or lake horizons level, because water at an angle looks terrible. Where there are mountains, you may not have a straight horizon, but any tilt of the camera will show up in the details. People, trees, telegraph poles and buildings will seem to lean.

Beware angling the camera up, to include a building. It will appear to lean over backwards. If you look at one edge of the finder, and line an edge of the building up parallel to it, the result shows a leaning building. You have to look at the centre of the building and balance this perfectly between the parallel sides of your picture. The 'convergence' of the vertical lines is acceptable if they balance and lean inwards an equal amount on each side.

Remember to use a vertical (upright) picture shape for tall subjects. This may alter your grip on the camera and make it more difficult to keep straight. Finally, make sure the picture you take is the picture you see. Squeeze the shutter gently, with one finger, without moving your hand. If you jab the shutter sharply, you may twist or move the camera a little just as you shoot, and the carefully lined-up composition can come out tilted.

Creative composition is something you have to learn for yourself, but good basic viewfinder composition is easily mastered.

EQUIPMENT

POCKET CAMERAS

The idea of pocket cameras is not new. The 'VP' or vest-pocket Kodak – a slim folding rollfilm camera – was popular in the 1920s and 1930s. There are two advantages in a small camera; first, it is no trouble to carry around and does not restrict normal activities. Secondly, people are less aware of the camera and behave naturally anyway, because they know it is a snapshot camera and are not apprehensive.

Modern pocket cameras normally take small film formats, either disc or 110. The camera bodies are, respectively, very slim or pencil-like, because of the shapes of the film disc and 110 cartridge. Small powerful batteries and electronic circuits make it possible to include motors to wind on the film and electronic flash, which needs no bulbs.

Many pocket cameras even have 2 lenses – a normal lens, and a portrait or telephoto lens which magnifies the image 1.5 or 2 times. These are built-in with no increase in size.

A larger format camera needs a separate flash and an extra lens in a case. The difference in size and weight is more than you would expect: halve the dimensions of a film format, and the camera's volume and weight is cut to one-eighth.

The only way to avoid missing spur-of-the-moment shots of people, places and things is to carry a camera all the time. The pocket camera fits a pocket, handbag or briefcase with equal ease.

Disc and 110 cameras simplify matters of choice, because they are only suitable for colour prints. If you prefer colour slides, family and friends will appreciate you carrying a second camera for prints. The same applies if you decide to try black and white, but still want colour records of your children. For the businessman, a good-quality pocket camera is the ideal notebook.

Professional photographers who would never normally consider using a camera with such small film will leave all their larger equipment behind and take a pocket camera on holiday. They understand how good it is not to be weighed down with equipment. Using a pocket camera can be showing consideration to people who are with you; they might feel that other activities were taking second place if you carry a big camera outfit around everywhere.

Limitations

The main limitation of disc and 110, as formats, is the relatively poor sharpness, coarse grain and limited maximum size of prints. At 'enprint' size (8 × 10cm/3¼ × 4¼in) results look good, but any degree of enlargement shows up the lack of

quality. It is impossible to take a small part of a picture and enlarge it selectively.

This means that pocket formats are rarely much use if you see a view and think you might like to produce a framed print later on. You either accept the restrictions or put up with a larger camera and enjoy the benefits of better sharpness and less grain.

Very few pocket cameras have accurate focusing. As there is hardly any need to focus carefully anyway, many have fixed focus on two or three click-stopped settings. Some have a sliding close-up lens for 1m/3ft distance and fixed focus for everything else.

The range of shutter speeds and apertures may also be limited. A typical maximum aperture will be f5.6, which admits a quarter of the light that a typical lens on a larger format camera passes. Action-stopping shutter speeds are unusual: normally there is a choice of just two. Sometimes these are set by the film cartridge and cannot be adjusted manually.

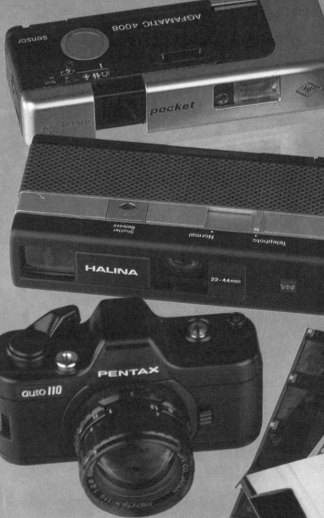

When the exposure is automatic, you cannot change it or compensate for difficult lighting conditions (this is explained, for other cameras, on pp. 74–7). If the exposure given by the camera is wrong, you may not have any warning, or see the fault until you receive the prints.

There are, however, some very high precision pocket cameras with 'fast' lenses, proper focusing and coupled rangefinders or even SLR viewing and interchangeable lenses. Some have top shutter speeds of 1/1000 and the ability to give long exposures, on a tripod, of up to 20 seconds.

Enthusiasts processing the films from these 110 cameras can make larger prints than normal, proving that the capability is there. Normal prints, too, from these top cameras are usually significantly better than expected.

Results

In general terms, pocket cameras give the best results when you fill the frame with the subject and use bright light. Direct sunlight or flash is ideal. Bright colours, clean simple shapes, close-ups of faces; all these work well.

You can expect poor results from muddy colours, very subtle scenes like misty days or distant views, groups of more than 5 people, flash shots taken more than 3m/10ft away, and any pictures taken in poor light.

Medium-speed film (ISO 100) gives much better prints than fast ISO 400 or 1000 film. Disc film is ISO 200 but specially improved; despite this it does not match the result of ISO 100 film in a 110 cartridge camera.

If you want colour slides, to be shown on a special 110 projector or mounted in adaptors for a 35mm projector, slide film is available for 110 cameras but not for disc models. Because the slide film is slow and has a finer grain, the results can be very good. Simple cameras designed for 100 or 400 ISO films only do not work properly with the ISO 64 slide film.

Black and white film is also made for cartridge cameras but is hard to obtain. It is not a particularly fine-grain, more a general-purpose film, and few photographers use it.

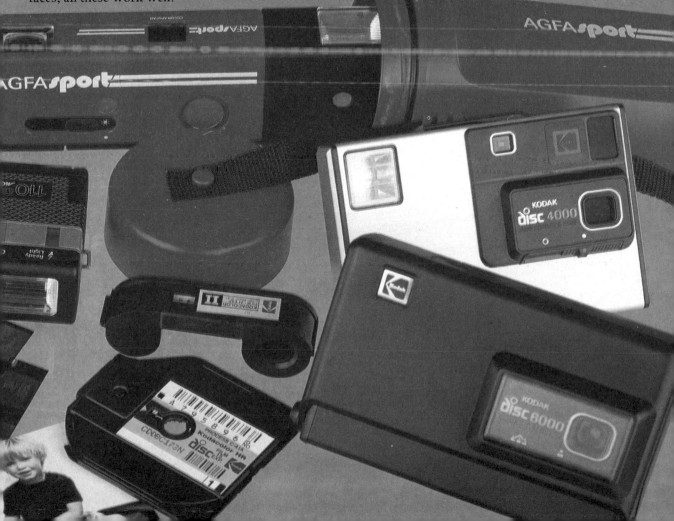

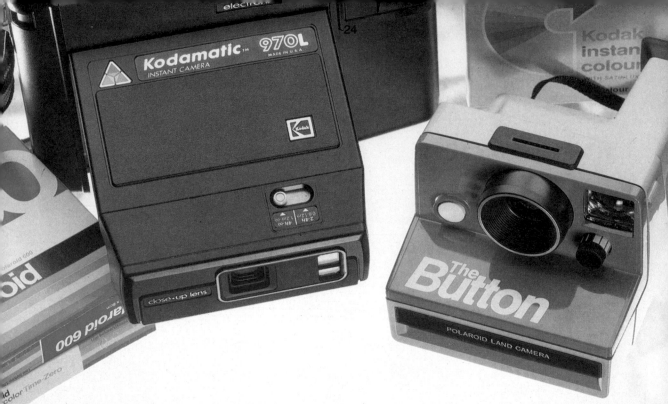

INSTANT CAMERAS

Immediately after you take each shot, an instant camera ejects a print. On older types you have to wind or pull the sheet out. Generally, you leave the print for 1 minute and the image gradually appears. After 10 minutes the colours are a little brighter and the print does not change any more, but after only 1 minute you can see whether the shot is a successful one.

Peel-apart instant prints have to be timed. After pulling the sheet from the camera, you allow 30 seconds to a minute depending on the type, and rapidly pull a backing sheet off. The finished picture is slightly damp and has to be left to harden before it can be handled. It does not change after you separate the 2 sheets.

Advantages

Having a print immediately means that there is no need to worry about failure. If you make a mistake or think the picture can be improved, you take another. You learn by your mistakes too, because you can see how different conditions affect the camera.

Most people like to be given a print of a picture you take. Sometimes, the picture is taken for this reason alone. Instant prints save remembering to send the print on; regardless of where you are, you can hand it to the subject, and then take another for yourself. It makes photography a more social activity.

Even when you do not want to give prints away, speed can be useful. Agencies selling houses or cars use instant cameras. There is no need to wait for processing and printing. If you are taking pictures on another camera, an instant print can be useful to help you see how a shot will look. Professionals use instant prints in their studio cameras before taking the final shot. Like a pocket camera, an instant camera makes a good 'notebook' for the businessman or traveller.

Disadvantages

Most instant cameras are big. Expensive ones fold up but are still much larger than pocket cameras. Some cheap models are very bulky. They cannot be used unobtrusively and many of them make a loud noise as the motor ejects the print.

Although the cameras cost little, the film packs work out more per print than ordinary colour film with processing and printing. Each instant print costs two to three times as much as an ordinary colour print. If you make a mistake and waste a print, it costs the full price. With ordinary film, the wasted shot is not printed and you pay only for the film itself, a negligible loss.

If you give away an instant print, you lose the original. There is no negative. Parting with a print means you can never make another copy. Even if you keep a print, copies are harder to make than prints from negatives. You need to take the print to

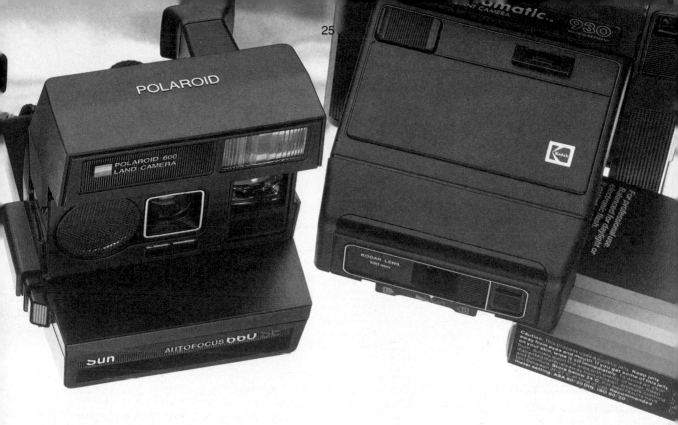

a shop offering a 'print from print' copy service, which costs more than normal prints.

Types

There are two popular instant print types: the Polaroid/Fuji system and the Kodak/Agfa system. The results are almost identical, costs are similar, and the main difference is in the cameras.

Polaroid instant cameras have the film pack on the flat base, and the lens faces forward mounted on a kind of pyramid, with a viewfinder on a stalk. The shape is boxy. The folding version is very neat and collapses to a flat cigar-box size. Each Polaroid film pack gives 10 exposures, with a square picture. The batteries are built-in to the packs, so you never need to buy any. Most of the cameras have a built-in flash which does not need bulbs.

Kodak instant cameras have the film at the back, and the camera is held flat to your face, with the lens and viewfinder near the top. There is a bulge in the front, like a belly, below the lens. The overall size is similar to Polaroid. Folding versions are similarly neat. The film packs take oblong pictures and do not contain batteries. Cheaper cameras have a crank-handle to eject the print; better models have a motor and built-in flash.

Instant cameras with no electronic flash take flashbars or flipflash. Though the camera costs less, most instant pictures are flash shots, and the flash-bars add 25% to the price of each print. Electronic flash is effectively free.

Special features

Autofocus is a very useful feature in an instant camera. It means you can take pictures quickly, and closer to the subject than normal. Most instant cameras do not allow you to be closer than 1.5m/5ft, unless they have separate focusing.

Fill-in flash is built-in electronic flash which works every time, even when you are outdoors in the sun. The camera has electronic circuits which measure the light, and the flash is controlled to lighten the shadows without affecting sunlit details. This makes the picture better, because instead of black shadows, you see detail. As soon as the light gets too low, the flash takes over entirely.

Copying attachments fit the camera and stand over a print. Usually, they use the camera's flash. If you buy one, it means you can make your own repeat prints straight after taking a picture.

There are some special instant print cameras for passports, ones which fit microscopes for hospitals and research, and others which can be used to make prints from your slides or ciné films. Professional instant cameras often use the peel-apart 'wet' processes but they can take colour, black and white, and even black and white with a proper reprintable negative.

COMPACT 35mms

The ideal camera is small enough to slip in a pocket and good enough to take sharp, grain-free pictures with fast film regardless of the weather or time of day. The 'micro' or 'compact' 35mm models come closest to this ideal and they are now the best-selling camera type.

There is no definite name for these cameras, because they are all slightly different. Most people call the slightly larger ones, with metal bodies and lenses which do not collapse, 'compact'. Very small models which probably fold or have retracting lenses and built-in dust covers, made of plastics, are called 'micro compact'.

These cameras have common features. They all take 35mm standard film cassettes, and this means they can be used for prints, slides or black and white and with films from very slow to ultra-fast. The lenses fitted are normally glass, unlike the pocket and instant cameras which often have plastic optics. The angle of view of the lens on a compact is wider than pocket or instant models and covers about 60°. Normal cameras see an angle of around 45°. Very few 35mm compacts are fixed focus or fixed exposure, and most have simple zone or symbol focusing with fully automatic exposure. This combination makes them easy to use and ensures sharp, correctly exposed results.

Camera features

The viewfinders on 35mm cameras are normally sharper, bigger and easier to look through than pocket or instant camera finders. They often have the kind of exposure displays or focusing aids mentioned on p. 19.

Rangefinder models have the central spot in the finder which splits the image in two. As you turn a lever on the lens to focus, the images gradually merge, and when they are coincident sharp focus is assured.

Symbol focus models have a scale showing the portrait, group and landscape symbols in the finder, so you can turn the lens and line the pointer up without taking the camera from your eye.

Autofocus models have a central aiming spot. Whatever this target covers will be in focus when the shutter is pressed, unless it is closer than 1m/3ft. If the parts intended to be in focus are not in the centre of the picture, you can half-press the shutter to set the focus, re-frame the shot, and complete the pressure to expose the picture.

Built-in flash switches on when you pop it up, normally because a light in the viewfinder tells you flash is needed. It is coupled to the film speed setting and the lens focusing (of whatever type) so that

you do not have to adjust anything to get the right exposure. A viewfinder light tells you when the flash is ready to fire.

Coupled flash fits micro compacts and links to the camera like built-in flash, but to keep weight down it can be removed. Many micros are sold with the flash complete and you never need to remove it.

Hot shoe flash is not coupled in any way, except for firing synchronization. You can use any make of flashgun. It slides into the accessory shoe on the camera top, which has a central contact to fire the gun. Any lens settings have to be done manually. Cameras with built-in flash or coupled flash do not normally have a separate shoe for other flash units.

Autoload compacts have a tacky spool and a film leader sensor. To load, simply lay the film in the camera so it touches the rubber take-up spool. As the back is closed, the film is pressed onto the spool surface. A motor advances to frame 1 and you are ready to shoot.

Autowind models wind the film on between each frame, and some of them allow you to take pictures in rapid sequence (1 per second) if you press your finger on the shutter continuously.

Auto-rewind senses when you have reached the end of the film (12, 24 or 36 shots with 35mm films) and the motor then winds the film back into the cassette, so that you do not accidentally open the camera when it is only partly rewound.

Autoload, wind and rewind are usually found together but some models have autowind only.

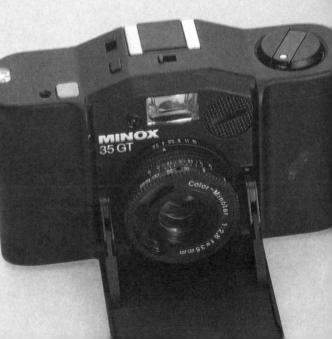

Choosing a compact

Each of these features increases the cost of a camera. The simplest compacts have symbol focus, a simple auto exposure mechanism and a flash shoe for any electronic flash. The most expensive have full autofocus, autoflash and motorization. These can even be built-in to a micro compact body like the Minolta AF-C Sightseer.

There are some models which are so small that their controls need delicate hands. Others are rugged and almost military in style, with chunky grip ridges, large shutter buttons and simple padded carry cases. Ask to see different models before ordering!

Are there any problems?

Nearly all 35mm compacts are so good that professionals own them as 'stand-by' cameras. The best ones are capable of tackling anything a more expensive camera will handle. If you intend to produce quality pictures and think you may one day want 20 × 25cm/8 × 10in prints or bigger, then a compact 35mm is far better for you than disc or 110.

The main problems are that built-in flash runs out of power beyond 3m/10ft, as with smaller cameras, and although the lenses are glass they may not be as good as other 35mm (SLR camera) lenses. Cheap or own-brand compacts can be poor optically and mechanically so it pays to buy a model made by one of the major SLR camera names.

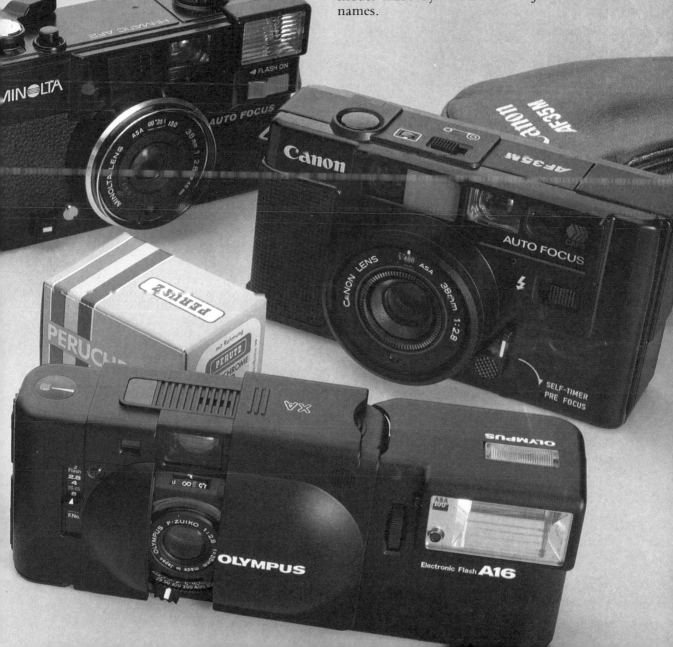

THE SINGLE-LENS REFLEX

The 35mm film size, with 24 × 36mm negatives, is able to make sharp enough pictures for billboard posters. For the best results the picture has to be very accurately focused, correctly exposed, and composed so that there is no wasted space on the slide or negative. This means: focusing through the lens itself; metering the exposure from the light which will actually record the image on the film; and, finally, being able to alter the magnification of the image so that different-sized subjects can be photographed from the same distance.

The SLR (single-lens reflex) has the advantage of through-the-lens focusing and viewing on the screen, viewed via the prism and eyepiece. The optics magnify the image so that when you put the camera to your eye with a normal (50mm) lens, everything seems life-size. The viewfinder looks very bright and sharp.

Inside the camera, light-metering cells and circuits measure the exposure from this same image. Coupled to the shutter and aperture controls, in most cases automatically, this TTL (through-the-lens) metering means that more shots per roll are correctly exposed than with compact cameras and others which have a separate 'eye'.

Lenses and accessories

On the front face of the camera body there is an opening with a machined metal bayonet mounting. Different lenses can be fitted. The standard lens is removed by pressing a button and twisting to release. The replacement lens is lined up, inserted into the mount and twisted to lock.

The terms for lenses are well known. A 'telephoto', as the name implies, magnifies the image and brings things closer. A 'wide-angle' sees a panoramic view. A 'zoom' gives a variable effect – some lenses go from wide-angle to telephoto, others can vary the image size within a range of different telephoto or wide-angle effects.

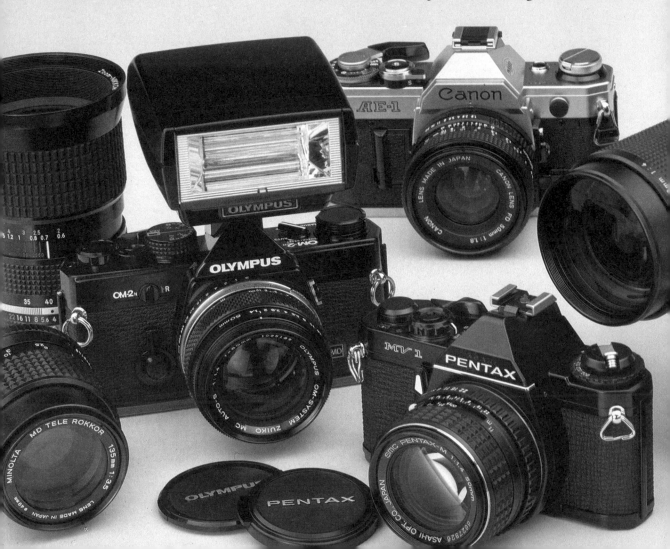

SLRs take other accessories which would be difficult to use on cameras with separate viewfinders, because they alter the focus or need to be aligned precisely through the lens. Close-up lenses and extensions which fit between the camera and lens make it possible to capture the eye of a fly or the details on a postage stamp with relative ease. Coloured filters can make a grey sky look blue or add sparkle to street lights at night.

Most 35mm SLRs do not have built-in flash. They have a shoe to fit coupled flash, linking to the camera circuits, but also able to work with non-coupled flashguns. A few have built-in motorized film wind but most take an accessory autowinder.

SLR features

When you look at 35mm SLRs you will find a barrage of information and technical terms. As most makers invent their own initials, phrases and descriptions it is a good idea to read about cameras

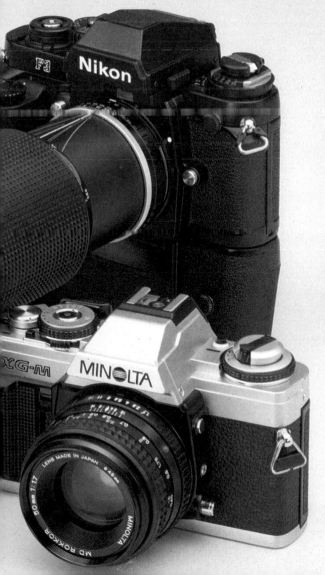

in magazines for several weeks before making a choice.

The basic features are TTL metering and interchangeable lenses. Additional common features are auto exposure, the ability to fit an autowinder, and 'dedicated flash' which couples to the camera.

Special features include auto or electronic focusing, a choice of viewing screens or viewfinders, high-speed motor drive, remote control, and extended shutter speed ranges. Generally, those cameras with most features, in any one range, tend to have them all together. A camera with no ability to fit an autowinder will probably not have dedicated flash or interchangeable viewing screens. One which takes a motor drive (faster than an autowinder, often 5 frames per second) probably has interchangeable viewfinders, remote control, data imprinting camera backs, underwater housings . . . the lot!

Auto exposure

There is no one type of automatic exposure in an SLR. Three different models in a range may all be automatic but each in a different way. Deciding which you need depends on what you want to do.

Programmed exposure sets both the shutter speed and aperture according to a pre-set scale. You have no decision to make and no option to change the camera's programme.

Aperture preference means that you set the aperture (also called aperture 'priority'). The camera then selects the right shutter speed and displays it in the viewfinder. To change the shutter speed you change the lens aperture.

Shutter preference works the other way round.

Manual setting or override either means that you can turn off the auto exposure and set both controls yourself or that the camera is not equipped with auto exposure to start with.

Multi-mode operation means that the SLR has a switch or dial to change from programmed to aperture preference, or to manual, and so on. Some models have three modes, some four, and in others autoflash operation is counted as an extra mode.

Bodies and lenses

You can buy a basic camera with a plastic body and one exposure mode for the price of a compact 35mm. From the same maker, you may find a precision multi-mode professional model at four times the price. The lenses, however, are normally identical. This means that the sharpness and quality of the pictures should be just as good from the low-cost model in a maker's range as from the top model. You should only buy the extra features if you intend to use them.

WIDE-ANGLE AND TELEPHOTO LENSES

Without a lens, your camera could not take pictures. Cameras with interchangeable lenses are supplied with one fitted as 'standard', costing little because it is produced in such large numbers.

The normal or standard lens for a 35mm SLR is one of 50mm focal length. This covers a diagonal view of 43°, a narrower angle than a compact 35mm. Experience has shown that 50mm is a comfortable length for most users: you can take a full-length portrait in a normal room, cover most buildings from the distance the architect intended them to be seen from, shoot landscapes, and take close-ups of an area about the size of this page.

There are also technical reasons why the 50mm has become the standard lens; in a compact camera, a wider angle lens closer to the film makes a slim body, but an SLR has a large swinging mirror between the film and lens. Lenses shorter than 40mm have to be special designs with more 'back focus distance' between lens and film than usual. The 50mm gives ideal clearance.

Cameras are offered with standard lenses which are 40mm, 45mm or 55mm instead of 50mm. Some 40–45mms may be slim designs with lightweight mountings. Try different makes to see which lenses you find easiest to view through and focus, and which combinations balance best.

Alternative lenses

An SLR with only 1 lens is not much more versatile than a fixed lens camera. Interchangeable lenses allow you to take in a wider angle of view (wide-angles) or magnify a smaller area to fill the frame (telephotos).

The further you go from the standard 50mm, the greater the cost, complexity, size and weight of the lens. The image size is proportional to the focal length. Compared to a 50mm lens, a 100mm lens blows up all dimensions to twice the size. A 25mm reduces them to half.

There is a limit to wide-angle effects. You cannot just go on doubling the angle of view. The practical limit is 110°, if you want straight lines like the horizon to appear straight in the picture. Lenses which cover 180° show everything curved. There are some special lenses which see behind themselves and cover 220°.

Telephoto lenses do not have a limit. They can go on magnifying infinitely, until you end up with the equivalent of a powerful star-searching telescope. In practice, the size and bulk of the lens goes up with every increase in magnification. If a lens is twice the focal length, it will weigh eight times as much! So there are definite practical limits.

In both wide-angle and telephoto lenses, size, cost and weight are reduced by using limited maximum apertures. This can restrict low-light shooting and make the viewfinder darker than normal.

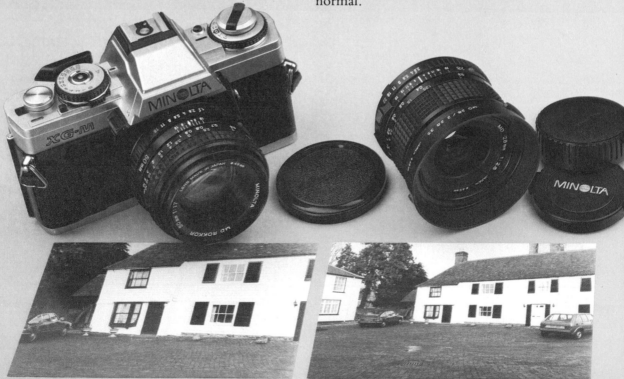

Wide-angles

The three popular wide-angle focal lengths are 35mm, 28mm and 24mm. The 35mm covers a diagonal angle of 63°. This is a very 'normal' angle; just right for outdoor scenes, groups of people, travel, streets, and anything where the picture might feel a little cramped with the 50mm. But you don't get the feeling of having a specially wide view lens on the camera.

The 28mm covers 75°, and although the difference is slight, there is no doubt that this is a wide-angle. The effect through the viewfinder is 'wide'. The 28mm is not suitable for portraits, as it means approaching too close. It is perfect for large groups, architecture, room interiors, landscapes with big dramatic skies, and shots anywhere constricted like on board a yacht.

The 24mm covers 84° and through most SLR viewfinders you can see that objects at the edge of the picture may look 'stretched'. Accidentally aiming the camera slightly up or down makes the walls of a room lean. A face close to the camera bulges unpleasantly. Many flashguns do not cover a 24mm lens view, so the edges of the shot are dark. It is not a good idea to own a 24mm and 50mm without having a 35mm or 28mm in between for more normal effects.

Tele lenses

The three most useful telephoto lenses are the 100mm, 135 and 200mm. Of these, the 135mm is by far the most popular first telephoto choice.

There are other lengths like 105mm, 120mm, 150mm and 180mm but they are rare. The 100mm is normally little bigger than a 50mm lens and covers 24°. Most 100mms also have fast maximum apertures, so they are good for low light and sports shots. In a small house or flat, the 100mm is best for portraits and shots of children. It is also good for landscapes and architectural shots when you can get back far enough.

The 135mm is the cheapest telephoto; every maker produces one or two, with different maximum apertures. It covers 18°, and in a small room makes it difficult to take a portrait except full-face. You will find a 135mm ideal for sports, zoos, candid portraits and public events like circuses, air shows and parades.

The 200mm, on the other hand, is difficult to handle unless you have experience. It takes only a little camera shake to blur the image because of the extra magnification. The 200mm covers 12½°. It is not suitable for portraits in small rooms, or for subjects like children where you want to stay close. Wildlife safaris, field sports, and events like water-skiing or motor racing where you cannot approach closer – these are subjects which suit a 200mm.

Think hard when buying your first lenses. Are you likely to buy more to want a full outfit? Pick a 35mm and 100mm, so you can add a 24mm and 200mm later. Want to stay light? Pick a 28mm and 135mm, ideal compromise lenses, and stick with them. Zooms are the only alternative.

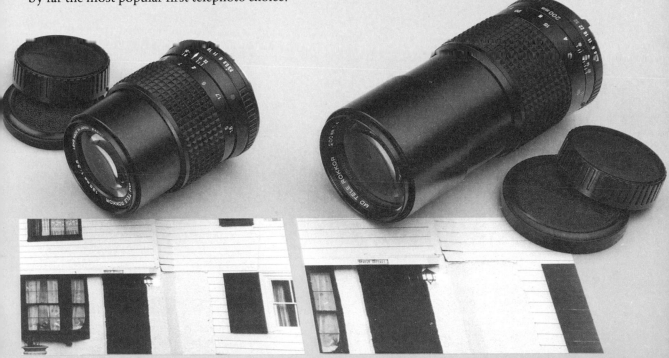

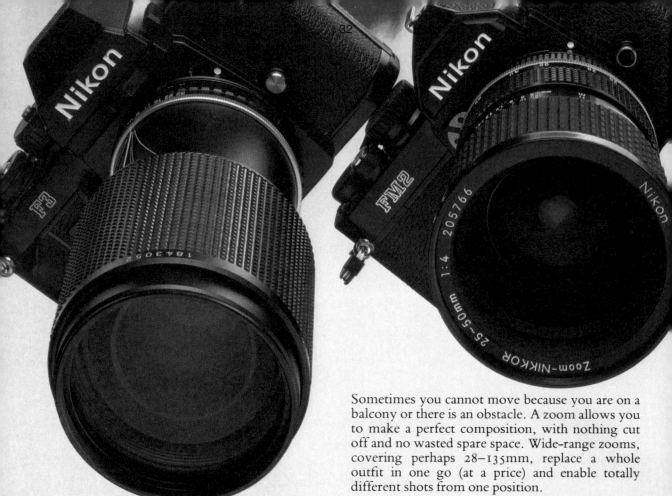

ZOOMS AND SPECIAL LENSES

Zoom lenses have a variable focal length range instead of one fixed focal length. As you rotate or slide a ring on the lens, the image size changes. It may go from wide-angle to normal, wide-angle to telephoto, or from medium telephoto to more powerful telephoto.

The disadvantages of a zoom are size and cost. Good modern zooms match other lenses optically. They cost about the same as 2 'prime' (single focal length) lenses of the same make and quality, and similar focal lengths. They are also about the same size and weight as 2 lenses joined together.

However, a 35–70mm zoom covers a 35mm, 50mm and 70mm (slight telephoto effect) range. It may be the size of 2 lenses but it replaces 3. You also get the benefits of every focal length in between – 38mm, 45mm, 55mm, 60mm or anything you care to set.

Instead of asking your subject to move a little closer, or having to shift position to re-compose a shot, you twist the zoom ring a few degrees.

Sometimes you cannot move because you are on a balcony or there is an obstacle. A zoom allows you to make a perfect composition, with nothing cut off and no wasted spare space. Wide-range zooms, covering perhaps 28–135mm, replace a whole outfit in one go (at a price) and enable totally different shots from one position.

Zoom types
You will have to decide for yourself which kind of zoom you prefer. Some cameras now come with a zoom like the 35–70mm mentioned in place of the standard lens, at a favourable price.

Twin-ring zooms have a rotating collar for focusing, the same as on all lenses, and a second for the zoom focal length setting. Because you do both separately, you can set the zoom to a fixed length then focus or vice-versa. There is no risk of altering one setting when operating the other. But you can only operate both together if the camera is on a tripod.

Single-ring or push-pull zooms have a single large collar which rotates to focus, and slides up and down the lens barrel to zoom. You can perform both actions together, but any adjustment may upset the other setting unintentionally.

Varifocal zooms are for enthusiasts with patience. Supposedly giving better optical quality or smaller size in exchange for inconvenience, the focus setting changes as you zoom, so it is necessary to re-focus after even a slight change in focal length.

Zoom lock lenses are single-ring models fitted with a lock so that you can fix the focal length, and

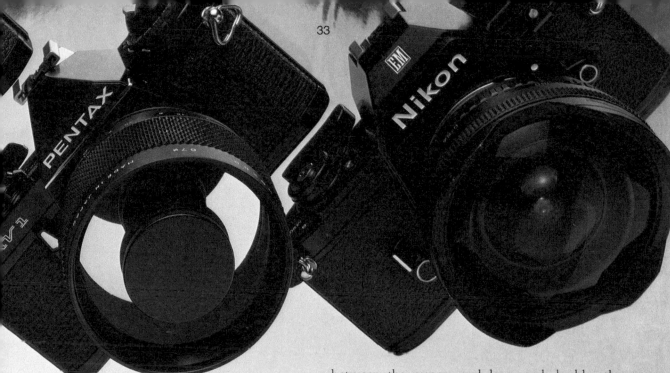

be free to focus with no risk of disturbing the setting. Some other lenses have a deliberately stiff zoom movement and free focusing action to achieve the same result.

What focal lengths?

Zooms get bigger and costlier as you increase their range and maximum aperture. A 70–260mm costs more than an 80–200mm and an f3.5 zoom is bigger and more expensive than an f4.5.

Because a zoom from around 75 to 150mm is no bigger than a 135mm telephoto, it is an ideal alternative. Similarly, a 75 to 200mm is no bigger than a 200mm, and replaces 4 lenses. Telephoto zooms are deservedly popular. Compare the size difference between 75–150mms and 75–200mms before buying; you may pause to consider whether the extra 25% magnification is worth twice the weight and bulk.

Wide-angle zooms are not so versatile for every-day photography. They can be expensive. Wide-angles are often used in confined spaces where a little movement changes the composition a great deal. Telephotos are used where you cannot approach close or move freely and the zoom gives vital flexibility.

A 24–35mm zoom may be no bigger than a 24mm on its own and solves the problem of which wide-angle to buy first; it covers all three popular lengths in one go.

Mirror lenses

For greater magnification, telephoto lenses and zooms can be fitted with a teleconverter. This goes between the camera and lens, and doubles the magnification at low cost. It is the ideal way to try out high power telephotography.

You may be tempted by a mirror lens. These are compact, light super-telephoto lenses with no aperture controls to set. They have to be used on a camera with aperture preference auto metering, or manual metering. The popular lengths are 300mm (×6 magnification compared to the standard 50mm) and 500mm (×10 magnification).

Mirror lenses look easy to use but they only give sharp, clean results on bright, sunny days. To keep the magnified image steady, you need a tripod or a shoulder-stock as well as a fast shutter speed like 1/500 or 1/1000.

Outfit logic

Never acquire lenses indiscriminately; you will spend more later changing them. Space the focal lengths evenly and always try before you buy. Don't have a zoom as well as a separate lens already covered by the zoom's range (except the 50mm).

To help pick your first extra lens, study your own pictures. Do you tend to show buildings with roofs cut off, groups without feet or shots of your garden which don't show enough? You would benefit from a wide-angle. If you have portraits with wasted space all round, sports shots with tiny distant figures, pictures of animals just a little too far away . . . try a telephoto.

Avoid extremes. Curved fisheye images amuse at first but soon pall. Money spent on super-fast optics for low light is wasted if you normally use flash. Some photographers need special lenses as tools and *need* should be the only reason for buying.

FLASH, TRIPODS, FILTERS AND CASES

Accessories fit all cameras, not just SLRs. An SLR system may include its own brand matched to the camera. Generally, you can buy any make, because the fittings are universal.

The two most important accessories improve pictures when there is not enough light. They are flash and a tripod.

Flash

The longest shutter opening time which most people can hold steady is 1/30th of a second. When the sun goes down or pictures are taken in a room with normal lighting, the exposure calls for a longer time.

Flash provides your own light, lasting a split second (from 1/1000 to 1/50,000), fitted to the camera so that wherever you aim the lens the light follows. Unlike a long time exposure on a tripod, it

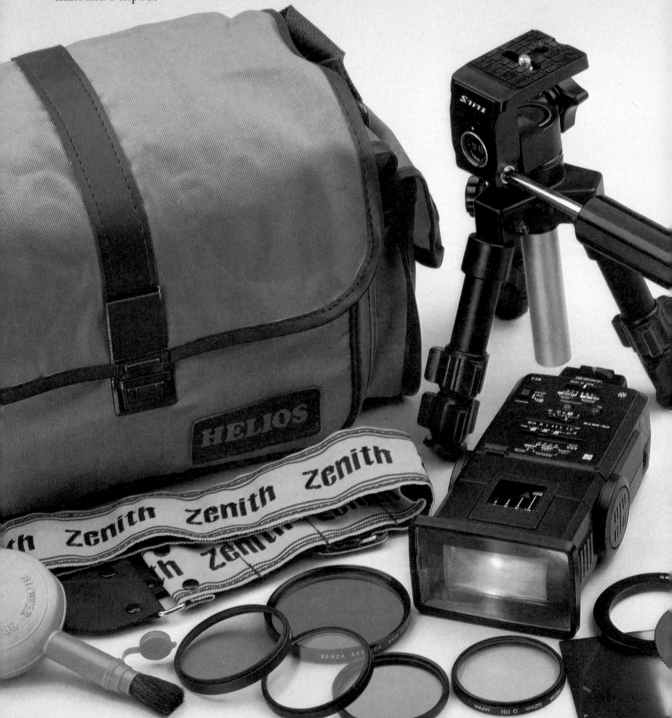

freezes subject action, so rapid smiles and gestures do not blur.

Flash does not reach far. Even with a powerful flashgun you cannot expect to photograph a stage performer from the back of a theatre; the limit is about 6–8m/20–25ft. On simple cameras it is often as little as 3m/10ft. Because the light falls off with increased distance, the background in flash pictures is often black, and people who are too far away come out too dark compared with those close up.

It is easy to make sure you buy a flashgun which will cover your requirements – ask for a powerful one! They are bigger than small flashguns. As a rule, flashguns which only use 1 or 2 batteries are good up to 3m/10ft or in small rooms; for bigger rooms and shots like groups of 6 or 7 people you should buy one which uses 4 batteries or recharges from the mains.

To operate a flashgun, fit the batteries and slide the flashgun into the shoe on the camera top. A few seconds after it is switched on, a light will appear to show that it is ready to use. In coupled cameras, the light may be in the finder. Only take another picture after the light has come back on again.

Tripods
Look under most cameras, even simple ones, and you will find a shallow threaded hole 6mm/¼in in diameter. This is the tripod bush. A tripod is simply a folding stand, with a head adjustable for rotation and tilt. The camera is screwed on to the head. Never pick the tripod/camera up by the camera, always by the tripod.

Tripods don't have to be large. Small clamps and pocket tripods are available for securing the camera to a door or putting it on a table-top. As long as the support is steady, the mini tripod will hold the camera just as firmly as a full-scale floor-standing model. You get what you pay for with tripods, and rock-firm models cost more than lightweight ones which are prone to vibration.

Use a tripod for exposures longer than 1/30th of a second, and for extra steadiness and sharpness on shorter shutter speeds as well. Some cameras have a 'delayed action self-timer' which fires the shutter 10 seconds after you release it. With a tripod, you can include yourself in a shot after setting the timer.

When the exposure time is long, moving subjects appear blurred in tripod pictures. Watch out for blowing grass or leaves – landscapes move! Sometimes, with exposures longer than 10 seconds, moving water or foliage make attractive fluid colours and shapes. Be careful to avoid knocking a tripod during exposure or allowing anyone to walk in front of the camera.

Filters
Filters are plastic or glass sheets which go in front of the lens to alter or colour the picture. You might pick a filter with the top half pale blue, to make a sky look bluer. A slightly pink filter, called a sky-light or haze filter, removes the cold blue feel you sometimes find in pictures taken on dull days. Some filters turn light sources like street lights or the setting sun into crosses or stars. Others make the picture look misty or soften wrinkles in portrait shots.

Most cameras accept filters, but to see the effect you need an SLR. You will probably see leaflets and advertisements, and will want to try filters because they cost little and the effects give a professional look to ordinary subjects. Don't let anyone put you off! Even if you have only used a roll or two of film, filters are fun. It is a good idea to take a 'straight' shot, unfiltered, as well as the version with the filter. Then you will not risk spoiling a shot by overuse or misuse of the filters.

There are some standard filters, like the skylight or haze, which can be left fitted on the lens. They protect the fragile glass from dust or moisture. Black and white photography has a different set of filters in yellow, orange and red which are intended to make clouds show up against the sky. A polarizing filter, like polarizing spectacles, cuts out glare and makes the sky seem a deeper blue in colour.

Cases
Camera soft pouches or fitted cases do not have room for film or accessories like flash. Sometimes, a small case can be fitted on the neckstrap to hold these. Lenses can be carried in their own cases separately, on other straps.

To keep everything together securely, an outfit case is a good idea. It can be a soft bag with a few padded dividers, to hold camera and accessories in their own cases. A hard suitcase-type with accurately cut inserts holds the equipment on its own, without using individual cases. Some fitted camera bags only take a specific size or make of outfit, but others are adjustable. Buy a lightweight case with a shoulder-strap, good waterproofing and a lock. If it doesn't look like a camera case all the better; it is less likely to be stolen.

TAKING PICTURES

HANDLING THE CAMERA

Once you have mastered the basic controls, features and optional accessories for your camera every picture comes down to a simple sequence: wind on, aim, focus, compose, shoot. Sometimes aiming, focusing and composing the shot are all a single action, and in some cameras the wind-on is motorized.

How you actually hold the camera and press the shutter can make pictures better or worse. Although speeds shorter (faster) than 1/30th of a second are supposed to be safe to hand-hold, this is only true for normal lenses and small prints.

When you use a zoom or telephoto lens, the shutter speed has to be at least equal to the focal length in millimetres. With a 200mm telephoto (on 35mm film) a shutter speed of 1/250th of a second is needed to avoid shake.

If very fine detail is important, or you plan to enlarge the picture as a big print or projected slide, shutter speeds must be at least two steps faster. With a 50mm lens you need at least 1/250; with a 200mm telephoto, 1/1000.

Often you simply cannot use these speeds, and a tripod is also inconvenient. So holding the camera steadily and handling it smoothly are very important for good pictures. The right grip on the camera also helps you to avoid tilted horizons and follow moving subjects.

The wrong grip and winding-on technique can mean camera shake, jerking the camera just before the shot so the composition is poor, or failing to see all the finder.

Holding the camera

Use both hands to hold the camera. Even if you are left-handed, you will have to use your right hand for the shutter, because cameras are built right-handed. The right hand takes a firm grip, using the ball of the thumb and fingers 2, 3 and 4. The first finger is left free to press the shutter, and your thumb should rest on the wind-on lever, which moves out slightly from the camera to allow this.

Slim pocket cameras like the 110 models cannot be gripped like this. Instead, they are held firmly between the second finger and thumb, with the first finger able to press the release. Usually the thumb wind is underneath where the thumb naturally falls.

Your left hand is free and should not be holding the camera except at the moment of shooting. Sometimes, you need to use the right hand to adjust a control, and change grip to the left. This is usually done away from the eye. At eye-level, the camera presses firmly against your nose or your eyebrow. Never try to hold a camera away from your face, even if you wear spectacles; with glasses, you should press them right against the lens.

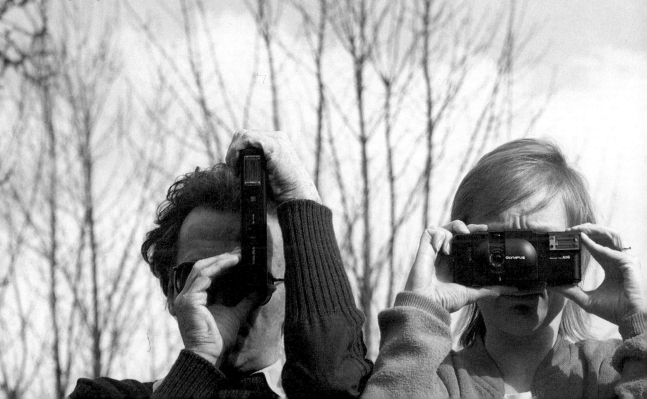

With this basic right-hand grip, the left hand is free to adjust focus and aperture controls on the lens. After setting, grip the left end of the camera body firmly with the left hand (35mm compacts, disc cameras and SLRs with small lenses). For greater support (SLRs with large lenses), cup the left hand under the lens or grip it firmly by a non-rotating part of the barrel.

People often find a grip with the hand cupped under the camera mount and lens very firm.

Vertical hold

Switching to an upright picture, the hand grip remains the same if the right hand is moved to the top position. This is suitable for quick changes. A much firmer hold changes the grip to cup the camera end in the palm, right hand underneath the right-hand end of the camera, with the little finger on the base and the thumb used to release the shutter. If your vertical hold is strained, you will probably end up with tilted pictures.

Wind-on

Even if you manage to wind on without moving the camera from your eye, you will find it hard to keep a steady aim. Do not try to use a 'motor drive technique' without a motor drive. After the first shot you will fail to notice how the composition is skewed, and most of the pictures will be tilted. It is better to remove the camera momentarily from the eye, wind on, then re-compose.

Shutter technique

Always *squeeze* a shutter release, taking it to the point of pressure then letting it trip gently. Never jab. If possible, rest the shutter finger on the rim of the release collar and fire by pressing with a slight pivoting action, so some of the pressure is on the camera body as well as the moving release. A soft or large release pad can help; some cameras have them built-in. You can buy 'mushroom' heads for others.

Cable releases

On a tripod, use a cable release. This is either electrical or mechanical and screws or plugs into the camera. A cable release is normally around 30cm/12in long and fires the shutter without any direct physical contact, thus eliminating shake.

Straps and cases and fingers

Be careful with built-in obstructions. Wear your camera on the shortest strap possible, with no spare ends unsecured. Remove ever-ready case fronts when shooting, rather than letting them hang. Keep straps, cable releases, cases, hair and fingers well away from the lens; you may not see them until the film is developed.

With built-in flash, remember that your grip must avoid obscuring not only the viewfinder and taking lens but also the flash. Your left hand is the one to watch – if the camera suddenly feels hot under your fingers when you shoot, you had them over the flashtube.

EXPOSURE DECISIONS

Sometimes you have no choice in how you use the controls on your camera. If the light is low and the meter indicates 1/30th of a second at f2.8, you cannot use 1/500 because that would need a lens aperture off the scale available.

In good light, you do have a choice unless you have loaded very fast film, which can leave you in the opposite predicament – a meter reading of 1/1000 at f16 and no possibility of using any other combination.

Stopping action

Even talking is action. Unless your portrait subject is holding a fixed expression, you need at least 1/125 to stop smiles, grimaces and changes of expression. If you photograph people in conversation try to use 1/250. A walking figure needs 1/125 at a distance, 1/250 closer to. A playing child needs 1/250, but if the play is very active (running, jumping, tumbling) you must use 1/500 or 1/1000. Indoors, switch to flash; it freezes action.

Slow or distant motion can be frozen at slow speeds like 1/60 or 1/125. A train, car or aircraft

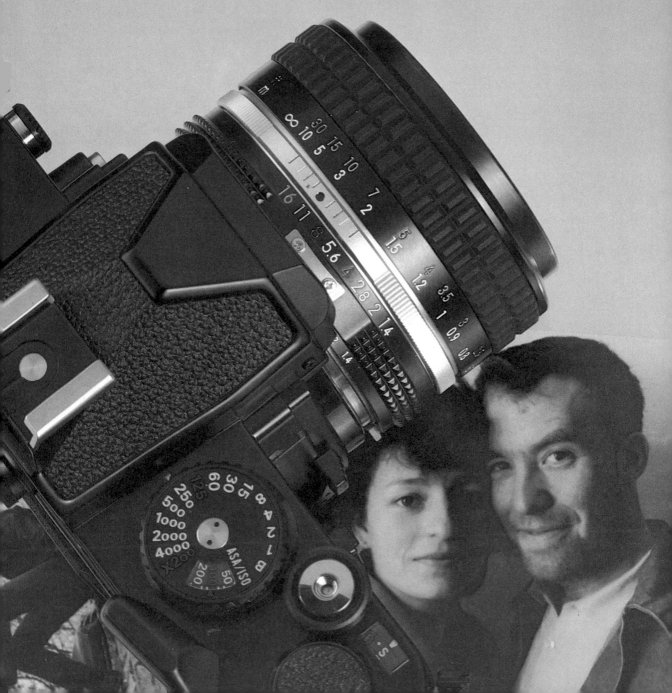

forming a small part of a scene will not seem blurred. Fit a telephoto lens or move closer and select a faster speed. A cyclist needs 1/250; traffic in a city street, about the same; slower vehicles on an open road, 1/500; motor sport, 1/1000.

Angles of action
These are simply guidelines for action moving around 45° to the camera. If the action is directly across the field of view or very close, go one speed faster. If the action is towards the camera or directly away from it, you can afford a one step longer speed.

Hidden action
A scene may look static but be moving very fast. Wind in trees, breakers on the shore, a waterfall or a game of cricket; all contain very rapid action in a fairly still scene. Select a high speed or part of the picture will be blurred.

Long exposures
Sometimes you encounter low light, like a city at night, where it might be possible to stop some action by using a wide aperture and a speed like half a second. People standing still, or cars stopped at lights, would show up sharply.

The problem is that moving people or cars show as short, ugly blurred patches; not sharp and not recognizable, but recorded. It can be better to stop the lens down and use an exposure like 30 seconds. Then if a car crosses the picture, a complete trail from its lights goes from one side to the other, instead of forming a short streak in space. Moving people disappear entirely. Moving water or foliage turns into a smooth fluid surface which can look fascinating.

Use the depth-of-field scale or preview on your camera to check and see which aperture is needed to bring the full depth into focus. Rather than put up with a slightly blurred foreground, go the whole

way and throw it totally out of focus; a vague blur of greenery framing a subject and overlaying it slightly looks better than a more distant half-focused intruding branch. To achieve this effect, put the camera as close to the foreground detail as possible.

Standby settings
Out in a well-lit street or on the beach, you may want to have your camera ready for anything. The sun is not threatened by cloud and for the next few hours the exposure will be more or less the same.

Pick a happy medium – something like 1/500 at f8. That would be the right combination to pick for an ISO 100 film on a sunny beach in summer. Grabbing the camera quickly and focusing as you aim, you can be sure that the 1/500 will stop any reasonable action and f8 will cover any slight focusing errors.

The same constant light occurs on a dull day in winter. With ISO 400 film, 1/250 at f5.6 might be the meter reading, and this would be a much better setting than 1/60 at f11 or 1/1000 at f2.8. You can always switch away from the standby setting to freeze action or secure maximum depth of field. It helps to be 'in the middle' with a safe compromise to start with.

Going for flash
Natural light looks good; flash is sometimes harsh. So when do you switch to flash rather than try to record existing light despite difficulties? Answer – when you risk losing the shot and when the light itself is not the reason for the picture.

A girl sitting by a window or lit softly by a fire will not look the same with flash; the natural light will be killed. It is worth trying a hand-held exposure, steadied by resting your elbows on furniture or leaning against a wall if you have no tripod.

In a disco, with flashing coloured lights, where people's expressions, clothes and actions are the real subject of the picture, flash would be used because if your subjects were asked to hold still for a natural light picture everything would be lost.

Middle-of-the-road settings
It is easy to know when to use 1/1000 or try a 30-second night-time exposure. It is harder to decide whether to use 1/60 at f4 or 1/125 at f2.8.

As a rule, assume that the *lens* is able to produce sharp images at any aperture when correctly focused, but your *hand* is not going to do the same thing at slow shutter speeds. Opt for a higher shutter speed if in doubt. The only exception is when the subject has depth, and you want to record detail in depth sharply.

THE LIMITS OF YOUR CAMERA

All cameras have their limits. There are some with long exposure time settings like 15 seconds. Most don't have this marked but give a long exposure on automatic when the light is poor.

The limits which are stated in the instructions may not seem to be the same as the ones you find on the camera. 'Maximum exposure time 4 seconds', says the instruction book. But you know that if you put the camera on a tripod and set the lens to f16, the camera will give a 20-second exposure in your living room.

The maker states the longest time which the camera is guaranteed to give accurately. If it seems to exceed any of its specifications, don't assume you have bought a model which has hidden benefits. It may be giving a long exposure – but the wrong exposure!

Limits and warnings

The focus scale is the easiest set of limits to tackle. At one end, there is infinity – anything over 30m/100ft. At the other, there is a close distance limit, like 1m/3ft or 45cm/18in. With an SLR camera you can see the viewfinder blur if you go too close, but it is easy to move in with an auto-focus, rangefinder, pocket or instant camera. The finder stays sharp.

Watch this all the time! If the book says the camera gives sharp pictures from 1.5–5m/5–15ft, it means it gives blurred pictures at 1.4m/4ft 6in.

With an autofocus camera the system may be thrown out of order and focus on infinity when the subject is closer than 1m/3ft. This makes matters much worse.

To cap it, most autofocus, rangefinder, instant and built-in flash cameras have coupled flash. The flash and lens are linked to the distance. If you go too close or the autofocus is fooled, you get pictures which are not just blurred but bleached white. If your camera has a warning to show when you are too close, never ignore it.

Although there is no far-focus limit, look at the flashgun or information panel. There is always a far limit for flash. Usually it is around 3–5m/10–15ft and applies to a domestic room with light decoration. If you take flash shots outdoors or in a big hall, halve the distance. Going beyond the limit means the shot comes out too dark or murky grey.

Exposure limits

Like focusing to infinity, exposure can be prolonged for ever – seconds, minutes, hours or days. Cameras with a 'B' setting, which allows the shutter to be opened and closed manually, give any length of exposure. Others cannot. Compact and autofocus cameras usually have a range of around 1/8th of a second to 1/500th. SLRs run from 1 second to 1/1000 plus B. Pocket and disc auto exposure cameras run from around 1/1000 to 20 seconds, but you cannot select the long exposure

manually; it is only ever given as a result of shooting in low light.

Cameras with a 'use flash' warning may not be able to take the picture without flash. They have already reached the limit of their settings. Those with a 'camera shake' warning give one or two longer shutter times, like 1/15 and 1/8, but the light suggests flash unless you want to make a deliberately long exposure. This also applies to 35mm SLRs.

Some cameras blank off the shutter release when the range is exceeded. Do not confuse this with a fault. If the display goes above 1/1000, and an overexposure light comes on, some makes will still allow release and set 1/1000 but others will prevent release. You can programme some SLRs to block release if the speed falls below 1/30th of a second, and to give an audio bleep warning to tell you to fit flash. The warning is optional and can be switched off. Others have it permanently built-in.

On manually set shutter dials, the speeds of 1/30 and longer are often engraved in a different colour, to remind you that they should only be used with a tripod or firm support.

Simple cameras

Cheaper disc, 110 and instant cameras have a fixed aperture lens and a single shutter speed. Slightly better ones may have two or three choices. This does not mean you can use them. The shutter speed may be fixed at 1/60 for ISO 100 film and at 1/200 for ISO 400 film, set automatically when the film is inserted. The result is the same – a single, fixed shutter speed.

Cameras like this use the natural latitude of the film – its ability to stand small exposure errors. They are set to be correct for a hazy, sunny day. Bright sun gives overexposure, a dull day underexposure.

It pays to know what settings a simple camera has. If loading ISO 400 film sets a shutter speed of 1/200, you can take reasonable action pictures with it, but not with ISO 100 film which sets at 1/60. Flash may have a limit of 2m/7ft with ISO 100 film. To get good results at 4m/13ft, ISO 400 should be loaded instead.

No simple camera will ever manage to take a picture of a musician at a concert from the back of the auditorium. Nor will it freeze a cyclist in a floodlit sports stadium. Using flash makes no difference. The flash runs out of power three rows in front of your seat.

Good pictures within limits

Stick to the stated limits and you will get good results with any camera. On a bright day, at 2m/7ft, a simple camera gives an excellent result with a static subject. If the composition is good and the subject interesting, the picture may be better than one of less merit taken with a superior camera.

Exceeding the meter reading, auto exposure, close-focus or flash distance ranges with any camera guarantees failure or faults. A full specification camera covers more conditions than a simple one but you still have to bear its limits in mind.

BASIC FLASH

Flash enables you to take pictures when there is no other light. All flash units are not the same. Some are powerful, some are weak and only suitable for close-up portraits and small groups. Some fit all cameras and others are made for just one.

Bulb flash uses small sealed glass bulbs full of aluminium wool. Each one gives a single burst of light and is then useless. Older flashguns may take separate bulbs, but new types include flashcubes, flashbars and flipflash, with from 4 to 10 shots at one loading.

Flashbulbs, cubes and bars are expensive. Generally the flash costs more per shot than the film and prints. If you run out of bulbs you cannot take any more pictures. The flash also has a long duration, 1/30th of a second, so it does not stop camera shake or freeze action. Separate flashbulb guns need their own battery but most current cameras fitting these bulbs have their own batteries built-in.

Electronic flash has a permanent tube instead of throw-away bulbs. The energy from batteries is stored in a capacitor and fired through the small gas-filled tube instantly. The flash costs more to start with, but after a hundred almost-free shots from a pair of penlite batteries it has paid for itself in flashbulbs.

Many cameras of all formats and types have built-in electronic flash. It may come on automatically or have a separate switch, which sometimes cancels a 'use flash' warning light.

Electronic guns with an accessory shoe fitting slide into the flash shoe of most 35mm cameras. The choice is large. Models which couple to a particular camera are called 'dedicated'. Large guns fit on a bracket which holds the camera, the flash acting as a handle. These are for professional and press use.

All electronic flash stops camera shake and freezes action, as it normally has a duration of less than 1/1000th of a second. You can use electronic flash for interesting shots where water drops, insects, birds and very fast movements are sharply frozen on film, and even the cheapest flashguns will give these effects. The skill and effort goes into setting up the picture and not into freezing the motion.

Distance and f-stops

Coupled and built-in flashguns adjust automatically to focused distances. Manual flash, whether bulb or electronic, has a scale with the film speed and focused distance. You read off the required f-stop after focusing. A typical electronic flash needs f5.6 at 3m/10ft with ISO 100 film.

Computer flash has a sensor eye, which cuts off the flash output at the correct exposure. A calculator shows the correct f-stop for the film speed in use and the distance range. You set the f-stop on the lens and keep within the range; exposure will then be correct. Better computer guns have a choice of three or four 'powers' for different f-stops and different distance ranges like 1–3m/3–10ft (f16) or 2–6m/7–20ft (f8).

Coverage: angle and depth

The flash obeys the Inverse Square Law and the illumination falls off with distance. To make sure all the important parts of the subject are evenly lit, try to have them an equal distance from the camera. Ask people to stand in a row, not as a group in several rows. Make sure no one part of the subject is more than 50% further away than the closest part.

Like your lens, the flash covers an angle. Most flashguns cover 40° × 60°. There is some light outside that, but it is not guaranteed to be even. This is enough coverage for a 35mm focal length lens on 35mm film. If you fit a 28mm or 24mm, the flash must have a wide-angle diffuser. Some guns have a panel you fix over the front, others a switch or zooming head.

Remember that the flash is often 15–20cm/6–8in above the lens. Very close to the subject, at a minimum focus distance like 30cm/12in, the 40° × 60°

field of the flash will be hitting the top of the subject only. The bottom will be dark.

The accessory shoe lines up your flash with the lens. If you have to hold the flash by hand or on a bracket, make sure it aims correctly. Any fault can mean one half of the picture looking dark.

With any 35mm SLR you *must* set the shutter to the recommended X (electronic) flash synchronization speed. If you don't, only a part of the frame will be exposed.

Red eye

When the flash is built-in to the camera and very close to the lens, an unpleasant effect can occur. Eyes have glowing red pupils instead of black. This normally happens when the subject looks straight at the flash, from a distance, in dim light so the pupils are wide open.

To avoid 'red eye', the flash has to be set 45cm/18in or so away from the lens, on a bracket. As there is nothing you can do with built-in flash units, a better remedy is to ask people to look at each other or turn the room lights up.

Ghosting

If you do have bright room lights, a second problem can occur with electronic flash (but not with bulbs). The X synchronization speed may be 1/60, and a weak flashgun might need f8. If there is a room light behind the subject and you are taking an action picture, it is possible for the flash to record

the subject for 1/1000th of a second and the camera to record the light for the rest of the 1/60, even if the subject has moved. To avoid ghosting, which can cut off parts of subjects, never have a light or window in the background.

Reflections

The flash itself reflects directly off windows, mirrors or polished surfaces. You do not see it beforehand, and often fail to spot it when the flash fires. Always watch out for reflective surfaces!

BOUNCE FLASH

Flash on the camera produces flat, harsh lighting which makes faces look like saucers. Sharp shadows can be cast on walls behind people, and 'red eye' may crop up. On the 'plus' side, eyes are well lit and sparkle with the reflected catchlight produced from the flash, and hair can also look very glossy.

To diffuse the light from a flashgun, it can be bounced off a suitable reflective surface. The surface must be above and between the subject and camera, or to one side and between. It should not be further away from the camera than the subject itself.

In a typical room, the ceiling is a perfect bounce surface. It is usually less than 1m/3ft from the camera, and the subject is normally 1.5–2m/5–7ft away. The flash is aimed 60°–90° upwards, bounces off the ceiling and lights the subject from above.

A good bounce surface is white and matt. Glossy surfaces produce uneven lighting; coloured surfaces colour the light. Cream or magnolia paint is much less effective than white.

In very large rooms, a high ceiling can be totally ineffective as a bounce surface. Some flashguns can be fitted with a small card in an angled holder, which replaces the ceiling. The light is not as diffused, but it is still softer than direct flash. This kind of bounce flash can be used outdoors as well.

Light loss and power

Flash has a limited range. When it is aimed at a surface to be bounced at the subject, the total distance involved (not the camera to subject distance) is the one to count. Flash to ceiling 1m/3ft, ceiling to subject 1.5m/5ft; total distance, 2.5m/8ft.

To this figure, add the light loss. The ceiling absorbs at least 50% of the light. To find the correct aperture, multiply the total bounce distance by two. Then check your flashgun; in this case, it would have to be powerful enough for the scale to go to 5m/15ft. Most do not.

Which flashgun?

Buying a flash with a special tilting head, intended for bounce, is a good start. Those guns which are too weak even for small domestic rooms cannot be bounced. Some makers are too optimistic and fit a tilting, revolving bounce head to guns which are not really powerful enough.

To be successful, the gun should take 4 rather than 2 batteries, and if a 'GN' power is quoted by the maker, it should be a metric/ISO 100 GN of at least 30. With automatic flashguns you never need to know what this GN power means, but trading standards say it should be listed somewhere. GN14 is very weak, GN20 so-so, GN30 a good medium power, GN40 powerful and GN60 a true blaster.

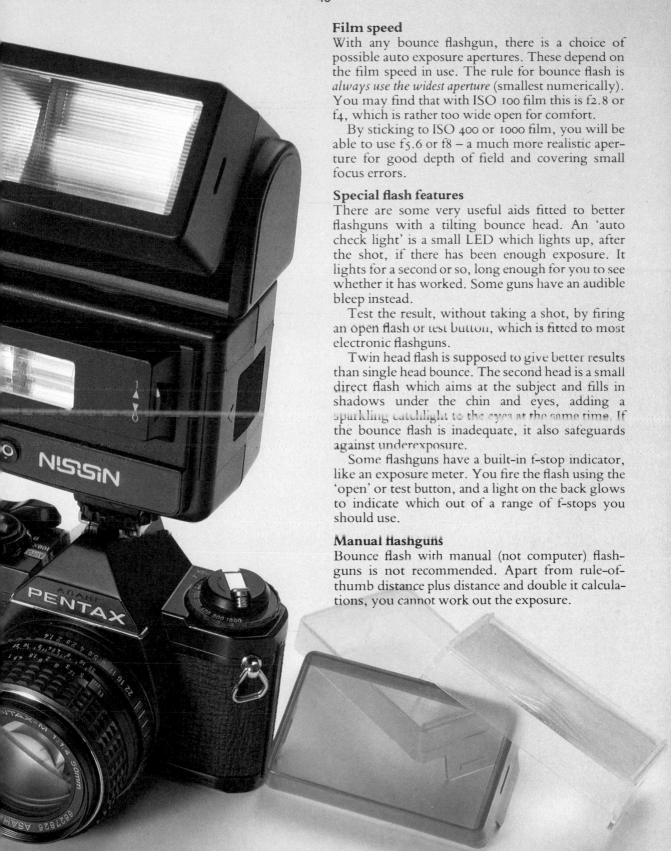

Film speed

With any bounce flashgun, there is a choice of possible auto exposure apertures. These depend on the film speed in use. The rule for bounce flash is *always use the widest aperture* (smallest numerically). You may find that with ISO 100 film this is f2.8 or f4, which is rather too wide open for comfort.

By sticking to ISO 400 or 1000 film, you will be able to use f5.6 or f8 – a much more realistic aperture for good depth of field and covering small focus errors.

Special flash features

There are some very useful aids fitted to better flashguns with a tilting bounce head. An 'auto check light' is a small LED which lights up, after the shot, if there has been enough exposure. It lights for a second or so, long enough for you to see whether it has worked. Some guns have an audible bleep instead.

Test the result, without taking a shot, by firing an open flash or test button, which is fitted to most electronic flashguns.

Twin head flash is supposed to give better results than single head bounce. The second head is a small direct flash which aims at the subject and fills in shadows under the chin and eyes, adding a sparkling catchlight to the eyes at the same time. If the bounce flash is inadequate, it also safeguards against underexposure.

Some flashguns have a built-in f-stop indicator, like an exposure meter. You fire the flash using the 'open' or test button, and a light on the back glows to indicate which out of a range of f-stops you should use.

Manual flashguns

Bounce flash with manual (not computer) flashguns is not recommended. Apart from rule-of-thumb distance plus distance and double it calculations, you cannot work out the exposure.

INDOORS AND LOW LIGHT

Light is responsible for much of the mood of a picture. Everyone is happier in sunshine and feels warmer on a cold day just because of the red glow of a fire. Rooms, in particular, get their atmosphere from the way the natural light comes in through the windows or the artificial light is arranged.

Catching the existing or intended light is always better than using flash. Use good natural light for portraits and still life shots, as in the group of pictures on this page; instead of being lit in a studio, the portrait shots were taken by a window. Professional photographers spend large sums of money on lights made to act just like windows. Real windows are free!

Will your camera cope?

Natural room light is much dimmer than outdoor light. Even when sun shines right into a room, it is about a quarter of the brightness outside. To photograph a face lit by sun through a net curtain, set a simple camera on the symbol for 'cloudy'. The sun usually only comes through windows late or early in the day, and you will discover that a simple camera cannot cope.

To take pictures indoors you need a shutter capable of 1/30th of a second or longer and a lens of at least f4. Auto exposure, or metering, is essential.

A tripod is almost vital, particularly if you have shutter speeds from 1/15 to 1 second and want to use them. One leading portrait photographer, who never uses flash and always puts his subjects near a north-facing window, says he takes every picture at 1/15th or 1/8th of a second. Most people can hold still and avoid blinking for this kind of exposure time. All the Victorian photographs you see were taken with exposures like this or longer.

Wide apertures

An alternative to speeds like 1/8 indoors is a fast lens – f2, f1.7 or f1.4. The camera meter will probably indicate that you can shoot at 1/60 or 1/125. The problem is that at such wide apertures, only a few centimetres will be sharply focused in depth. Very careful angles and composition can avoid blurred parts on the subject, but if you plan to use wide apertures to shoot a child playing (or another moving subject) the success rate will be low.

Fill-in flash

To sharpen up an indoor picture taken by existing light, even at a time like 1/8, you can add weak flash. Only try this with a computer flash or one with variable power. Set the flash to its weakest power

or widest aperture. Bounce the flash off the ceiling or wall to cut its power, if it is not variable. Bounce flash as a full light source on its own is covered on pp. 44–5.

Window light

For a window-light portrait, pick a large vertical window overlooking open space (not facing heavy trees or a wall). Avoid direct sun entering. Stand your subject just to one side of the window, looking across to the other, about 1m/3ft away from it. Take the picture from the other side, missing out the window itself. Open draped curtains often make a good backdrop with this composition.

Large windows give good light immediately below them for subjects lying down – anything from a baby on a sofa to a nude figure study. Rooms with several windows may have patches of very good and interesting mixed light easily identified by walking round the room.

Tungsten light

Domestic light bulbs are so weak that they need long exposures, like 1/30 at f4, just to record on the film when included in the picture. It depends on the wattage; a 60W bulb in a shade needs more and a bare 150W much less.

To make a good tungsten portrait, take a table-lamp with a plain shade and a 100W bulb. Put it on a light-topped table or a white cloth, so the pool of light falls on a reflective surface. Ask your subject to sit with one elbow in the pool of light, just behind the lamp, chin resting on hands. Take the exposure reading from the face. The effect is a warm, glowing natural picture and the exposure may be as long as 1 second at f8.

Fireside

Light by a fire is so dim that the best idea is to turn the room lights on as well. Use whatever light seems right to the eye, but don't include the lights themselves. Take your exposure from the room light in general, not from the fire.

Outdoors, by bonfire-light, the best idea is to let the camera take care of exposure. Use a fast film (400 or 1000) and you will find that exposures are about 1/30 to 1/60 at f2.8.

Sunset light

The last rays of the sun, rather than the sunset itself, are not much brighter than domestic light. Occasionally you will see a subject picked out by vivid red or pink rays. If the sky is still blue behind it, all the better. Do not be surprised if the exposure is around the 1/30 at f4 mark, although the sun is still 'out'. Simple cameras cannot take pictures in this kind of sunshine.

Street lights at night

To make good pictures, street lighting needs the right weather – fog, rain or snow. In fog, the light is diffused to fill the black spaces between. In rain, each light may give a long ribbon of reflection. In snow, the ground is white and everything becomes suffused with reflected brightness. Whatever the exposure, try varying it by changing the ISO film speed setting or (on manual) either the aperture or time. As a guide, use 1 second at f8 with ISO 100 film and city centre lights.

PHOTO SUBJECTS

PORTRAITS

People are the most interesting subjects. Glance at any family album, television programme, advertisement or newspaper to confirm it. The first bit of a person we look at is the face. We recognize people by their faces, and judge their mood by expressions.

Portraits are likely to be the most appreciated pictures you take, by others as well as yourself. Although some people always say they do not photograph well, and criticize their portraits, their concern shows their interest!

You can take portraits with almost any camera in good light, and sometimes a casual picture with a pocket camera will be much truer to life than a posed studio shot.

Composition

To keep the facial features in proportion, keep at least 1.2m/4ft away. Any closer, and you may end up with large noses and small ears.

A good portrait has a little clearance above the head and enough body to balance the shot. A head and neck with no body looks wrong. So does a head touching the top of the print, like someone in a doorway which is too low for them. Remember to turn the camera for a vertical, upright format shot. Generally this suits portraits much better than a landscape, horizontal format shot.

Full face

For a full-face shot, you will probably need a tele-photo lens on a 35mm SLR. With compact 35mm and pocket cameras, the closer in you can move the better. Some pocket models have a sliding 'portrait' lens which is like a telephoto, and disc cameras accept attachments to magnify the image × 1.5. But these do not mean you can come closer; usually, you must stay 1.5m/5ft away.

To improve a full-face shot, ask the subject to stand slightly sideways, then look back at you a little. This puts the face in three-quarter view, with both eyes but only one ear visible. Rather than have the head dead straight up the frame, ask your sitter to tilt his or her head slightly – or tilt the camera if there is a neutral background like a plain wall.

Head and shoulders

With a 35mm camera and standard lens, or a pocket 110/disc camera, your closest normal portraits will be head and shoulders. To avoid making the body

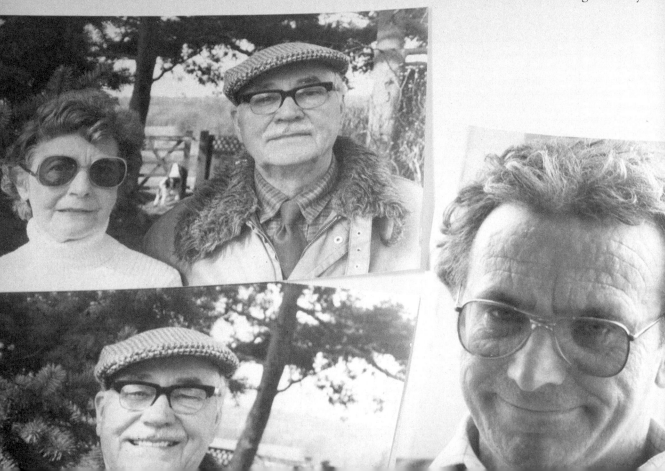

look broad, have the subject standing almost sideways-on to the camera, with only the face turned towards you (as for a full-face portrait).

Women look slimmer if you do not include any space round the shoulders, but crop slightly in to the silhouette. In a typical head and shoulders shot, the mouth will fall in the centre of the frame. Resist putting the eyes dead centre, or there will be too much space above the head.

Three-quarter length

Turning the body is important in three-quarter shots. It is even better to get your subject to sit on a high stool or lean. A natural relaxed pose looks best. One hand in a pocket, one out; one resting on a fence, one holding a stick; these are good poses. Folded arms, hands behind the back, hands in pockets or straight down by the sides . . . are bad!

Double portraits are best three-quarter length. Use the camera landscape way on, not vertically, and have the subjects facing in towards each other. This is how group shots can be composed; half the group faces in from one side, the remainder from the other.

High and low viewpoints

Make legs look longer, and people look taller, by kneeling when you take the picture, so you look upwards. Chins look bigger and foreheads smaller. Standing, with a sitting subject, has the reverse effect and makes them look small, with big foreheads and small chins.

Lighting

Bright sun makes people screw up their eyes, so never have portrait subjects facing the sun. Instead, use backlighting, or move into shade. The best portraits are taken on bright overcast days, with soft, even lighting.

Strong backlight, with the sun shining through hair, can be attractive for women and children. Slanting sun, cutting across the face and picking out every line, works well for a male portrait.

LANDSCAPES

The great outdoors never looks as good on a postcard-sized print as it did when you were surrounded by light, air and distant sounds. We get our impressions of outdoor space from all the senses, not vision alone.

You can improve landscapes by concentrating on scale and depth. To record scale, make sure that a mountain looks solid and mountainous in a print, and not like a distant grey hillock. To record depth, the distant scene should relate to the foreground and middle distance.

Landscape photography has more to do with composition and using the viewfinder than any special techniques or ideas.

Scale

Any distant scene photographed on a simple camera will be disappointing. The fine detail which the eye saw is lost, and the size of things is not clear. This applies particularly to large expanses like sea, desert or moorland.

Using a wide-angle lens, to 'get more in', makes things worse. It is better to fit a telephoto and enlarge a section of the scene. Mountains look best photographed on a telephoto lens, filling the frame, with very little sky above them. Try to decide which part of the view is the interesting element and what parts are just surroundings, then close in on the vital bit.

Depth

A single plane has no depth. If you can include some closer detail, the perspective is improved. Try turning the camera to a vertical composition to include more foreground.

Depth can be shown by something reducing in size with distance. Trees, perhaps in a row, or telegraph poles down a road, a winding river, overlapping hills – these things show depth.

Framing the scene with a foreground acting like a window works well. Use a gap in the trees or a break in a wall. The foreground should occupy around a quarter of the frame, holding the picture in. Sometimes a foreground element which frames a shot on one side only is acceptable.

Perspective

The 'perspective' is the relationship between foreground, middle distance and background. If a single flower fills the foreground and a mountain range forms the background, the perspective is strong or 'steep'. This effect can be produced by moving close to a small foreground with a wide-angle lens.

A compressed perspective is created by telephoto lenses. The classic example is a shot down a dusty country road with telegraph poles visually stacked up, hardly seeming to get any smaller with distance. Steep perspective is more exciting, but on the right subject compressed perspective can be powerful.

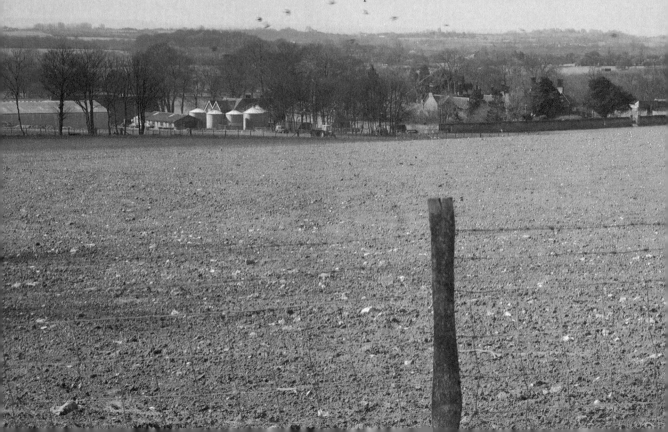

Viewpoint

Vertical things look smaller from above or below; horizontal things look smaller if you look along them from one end.

This is why a mountain face looks unimpressive from its foot, and a lake fails to have impact when photographed from the shore. To make a mountain look big, your best viewpoint is on another mountain, facing it, halfway up. The same applies to a rock, a tree or a waterfall.

Lakes and valleys look most impressive if you climb to a high viewpoint and look down on them. Then their size is spread out below you. The patchwork pattern of fields, ploughing or forest trees shows up well from high viewpoints or facing a hillside.

Horizons and skies

In a landscape, keeping the horizon straight is important. If the picture is divided exactly in half some impact is lost. Keep it about one-third below the top of the picture, or closer.

When the sky is dramatic, try a shot with two-thirds sky. A silhouetted tree adds interest. It is only worth doing this with skies where blue is patterned with clouds. Plain blue or white skies rarely make a picture!

The sky gets lighter towards the horizon, so do not expect a thin band of sky to be deep blue. If you want a deep blue, include more sky by using a wider angle lens and a vertical composition.

Human interest

Figures in a landscape add scale, when they are distant. Closer to the camera, they add colour and human interest. The hues of a typical landscape may not be very varied so clothes and skin add new tones. Activities add clues to the situation; fur coats and boots emphasize the cold of a snow scene, bikinis the heat of a summer scene. Remember that farm animals, vehicles and boats also add interest.

Weather

For landscape shots, the weather should suit the scene. Thunderous clouds and bleak rock pinnacles over a windswept moor go well together. Early morning sun suits a brilliant green spring meadow. Autumn views look good in mist or at sunset. The only 'killer' light for landscapes is a dull, overcast day. Seasons also alter landscapes; there are months in winter where scenes ideal for summer shots are not worth aiming a lens at.

Exposure

When in doubt, expose the landscape for the ground detail. Take a reading by aiming the meter or camera down. Always do this except when there is a deep blue sky on a sunny day. For dramatic shapes against the sky, take a reading direct from the sky itself.

ACTION PICTURES

Don't think of 'action pictures' in terms of sports, motor racing and so on. Action pictures start with anything from the family dog running across the lawn.

You have two problems to contend with apart from the relatively simple business of using a fast enough shutter speed to freeze the movement. First of all, you have to aim the camera and follow the subject so that when you finally press the shutter, everything is actually in the picture. Secondly, you have to keep it in focus.

It takes a good deal of skill to follow the subject and release the shutter on time without trying to focus as well. Not even the most experienced photographers like doing this. Television camera crews have 2 operators – one to follow the subject and the second to change the focus.

Action speeds

The shutter speeds you need to stop action have been mentioned already (p. 38). The kind of move-

ment that can be stopped with a simple camera is limited. You have to time the exposure just at the peak; a jump in the air has a point at the top where the movement is neither up nor down. If you can catch this, even 1/30th of a second will freeze the movement. Gravity is doing the work for you.

With any adjustable camera, the secret is to use the fastest speed you can afford. A running man will be stopped just as well by 1/1000 as 1/500.

Another trick is to shoot the subject coming straight at you. If you stand beside the straight section of a race track and photograph the bend where cars come round in a group, a speed like 1/125 will 'freeze' the cars. Moving directly across the field of view even 1/1000 would not.

Panning

Panning is nothing more than following the subject. It cannot be used for complex movements like a diving into a pool with a somersault, but whenever the action is directional you can pan.

Keeping your eye to the camera, follow the subject as it comes into view. *Without pausing*

Pre-focusing

Use the same technique to focus, especially with telephoto lenses and at wide apertures, when focusing is critical. Pick a reference point which the subject is bound to pass. In showjumping it is normally a fence. In circuit or track events it may be a marker post or a patch on the track.

After focusing on this spot, do not adjust the focus again. Pan with the subject as it comes into view. It may be out of focus through the viewfinder, but you have to ignore this. As it approaches the chosen spot, it will sharpen up. Don't try to judge the sharpness – just wait for the moment when it passes your reference point and fire the shutter a fraction before. This is to make up for your own delayed reflexes. Keep panning through.

With autofocus cameras, pre-focusing is not necessary, but it is still useful to pre-frame and to press the shutter well in advance. Autofocus mechanisms add an extra delay to the timing, and if you fail to press early and follow through, the subject may have passed the best spot or have even left the field of view.

Ensuring fast shutter speeds

There are simple ways to get the highest shutter speed when needed. The basic one is to use a high speed film, ISO 400 or 1000, which will give settings of around 1/500 to 1/1000 on bright days when an ISO 100 film gives speeds of around 1/125.

When manual or aperture priority settings are provided, use a wide aperture. This results in a higher shutter speed either by manual metering or auto setting. If the camera has a system which prevents release should the speed go above the 1/1000 mark, adjust the aperture so that the speed is between 1/500 and 1/1000. This reduces the risk of losing a shot.

Shutter priority automatic cameras are easily set to give high shutter speeds, because you select the speed first. Set 1/1000 and see if the aperture indicator falls within a reasonable limit (say f2.8). Some makes will override and give extra exposure if the lens reaches full aperture and there is still not enough light.

Fully automatic programmed cameras, whether disc, 110 or 35mm, can be influenced to give higher shutter speeds only by using a fast film and taking your action pictures in bright sunlight. Instant picture cameras with fast film like Polaroid 600 do not give action-stopping speeds; instead, they use very small apertures to cut down the light. Electronic flash indoors freezes action with any camera.

follow through, and as it reaches the right size in the field of view, press the shutter. *Keep on panning* – like a golfer, you have to have a follow-through.

A smooth pan enables any camera to catch any speed of action. The subject may not be perfectly sharp, but very close to it. The background may be blurred, and if you deliberately pan with a shutter speed like 1/8 this can turn into streaks which convey motion.

With panning, even the simplest camera can take good action shots. Pictures look better with the action entering them rather than leaving, so compose the shot with space in front of the subject rather than behind it.

Pre-framing

Most track sports have easy fixed points where you know the subject is going to pass by. Watch to see where the action takes place, and how much space you need to get the subject in. Move to a position where not too much frame is wasted, but you still have leeway for errors.

CHILDREN

A record of your own children is something photography can give you to value for a lifetime. Children make bright, amusing and appealing subjects even if you don't have a family of your own.

Bad pictures of children are appreciated. Good ones are praised beyond all merit! Take photographically excellent pictures of kids, and you will be in great demand.

There is no point in copying the posed, formal portraits which any school photographer will guarantee to take to perfection for less than the price of a roll of film. Lively, unposed shots of children playing in the home, on holiday, out walking, on the sports field, with pets or at school are much better.

Simple tips

A grown-up talking to a child bends down, or lifts the child up. Only unfriendly or severe adults speak to small children from full height, looking down on them. Photographs should be taken on the same basis – lift the child up to lens-level, or get down yourself to child-level.

Get close. Don't worry about the rule of not taking a picture closer than 1m/3ft, if your camera will focus closer. Children's faces are not distorted unpleasantly by moving close, because they have small noses and rounded cheeks. Remember 'get down and get close' whenever you take pictures of children.

Playing and making friends

Never make it clear that what you want to do is take pictures. As soon as a child is old enough to understand what this means, everything stops being natural and happens instead for the benefit of the camera. What a 5-year-old considers to be a smile may not be exactly what you had in mind.

Keep the camera incidental, whether with your own family or others. Join in, talk, laugh, make jokes, play or allow yourself to be accepted. Then use the camera quickly, naturally, without thinking.

A good trick is to ask to take a picture of a toy or a pet, or something the child is *doing*, rather than a picture of your real subject. Most kids are delighted that you want to photograph their sandcastle, their car, or their rabbit. They pose or play with what they think you are photographing and act naturally. In fact you are taking pictures of them and the 'subject' is just a prop!

Easy cameras are best

Complex 35mm SLR systems are not necessarily the best models for child pictures. The ideal camera is an autofocus motorwind compact with built-in flash. Because there are no adjustments to make you can shoot quickly and catch every moment. Second choice is a pocket disc or 110 camera with no need to focus, looking very harmless and more like a toy than a camera. But these rarely focus close.

Flash and action

Kids move fast, and their expressions change more freely than adults. Electronic flash is ideal for indoor pictures. You can take good shots at bath-time and bedtime, when the concerns of the day are over and faces are clean.

Outdoors, use a fast film or aim for fast shutter speeds, at least 1/250th of a second, because of the natural activity of the subject. If dirt or rough play are part of the situation, accept it! Children look best photographed the way they are, even if that is not Sunday-best.

Telephoto and candids

Tele lenses, which allow you to stand on the sidelines and watch groups of children at play without getting involved, also reduce the sense of closeness in the picture.

You can use a telephoto for children in general, to show a scene which is mainly a photograph and only partly a record of children. Used on your own family shots, a tele lens will tend to add remoteness and make things look rather as if you were an onlooker and not part of the scene yourself.

Candid shots, with the subjects totally unaware that you are there, can be winners. The interaction between children is fascinating: a conversation, playing together, a fight, a formal game – a world of their own

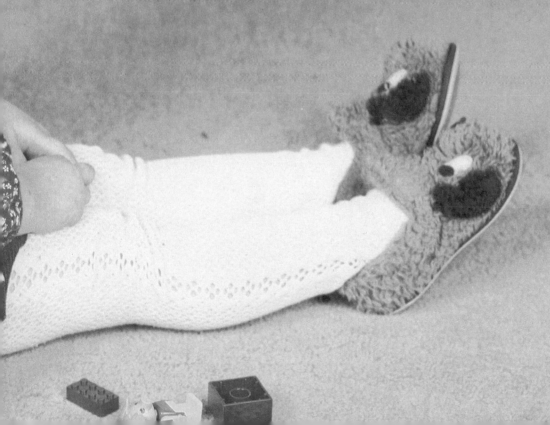

ANIMALS

Animals make good photographic subjects when you can get close enough to show them properly. There is no problem with domestic dogs and some farm animals, which are so friendly your difficulty may be keeping them away from the camera. Smaller pets and wild animals or birds keep their distance.

To fill the frame, even with pets, you need to have a telephoto facility. The 110 cameras with sliding tele lenses and disc models with attachments are better than those without. On a 35mm SLR, a zoom from 80–200mm is ideal for nearly all types of animal photography.

Close focusing is not so important. Every creature has its distance; if you come closer, it backs away. Birds stay about 3–4m/10–13ft from humans except in public parks where they are used to being fed, or in a garden with a feeding table. For 'close-ups' of small creatures you need a powerful telephoto, not close focus. This means a 35mm SLR and a lens of 300–500mm, probably a mirror lens for light weight.

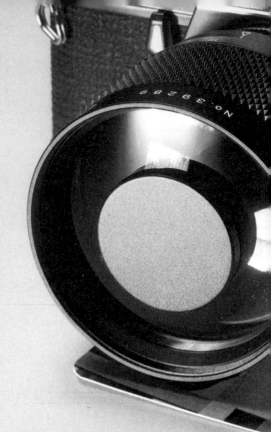

Pets

Human faces are flat, so look best from the front. Some animals also have flat faces: pug dogs, puppies, cats, owls and apes. But most have long noses and narrow heads, like dogs and horses. The best angle is from the side. Front views give head-shape and depth-of-field problems, and often the eyes do not look forwards.

The same applies to body shape. People stand up, but animals have long bodies behind their heads. An angle which shows most of the body must be at least a three-quarter side view. The tail is often important, too, and should not be hidden.

Action shots of family pets are more fun than portraits. It's a good idea to include people. Cats and kittens look much better held near a happy face. If you cannot include people, then you must take a strong close-up. Cats' faces, which have little depth and very big eyes, make excellent close-ups.

Small creatures like pet mice should be held in the hand. Ask a child to hold the mouse up a few centimetres in front of his or her face, at eye level, so you see the mouse right in front of the child. Go as close as the camera will allow. Otherwise, you end up with a tiny mouse in a big portrait shot.

Classical portraits of pets, to convey the qualities of a show champion, need to be posed the way that a judge would expect to see the animal. Professional animal photographers know exactly how to pose each breed and show it to its best advantage.

Zoos

The best animals to photograph in zoos are the ones which stay in the middle of their cage or compound, away from the wire or bars, but awake, active and interested in visitors. Big cats, apes, bears, seals, monkeys and many birds all do this.

Eyes and expressions are important, so animals which look at you make better shots. Very fast moving ones are hard to catch because the light in zoos may be subdued, and animals prefer to stay in the shade except when basking (which is hardly an active pastime).

Don't worry about wire, bars or glass. If the camera lens fits just between the bars, or rests against the bars so that they do not obstruct the finder image, use your hand round the front of the lens to stop damage and rest solidly against them.

Finer wire can be 'lost' by using a telephoto lens or a very wide aperture like f2. The wire is right in front of the lens – put the camera against it. Because it is so close, it is entirely out of focus and doesn't show. Be careful to use a depth-of-field stop down preview on an SLR camera if you are using an aperture like f8. You may think the wire is no problem, but with the lens stopped down it will show.

Good zoo shots have a natural background, not bricks or fences. Use differential focus (at a wide aperture) to throw the background into a blur if it isn't appropriate. Ideally, look for greenery or dusty earth, to suit the animal.

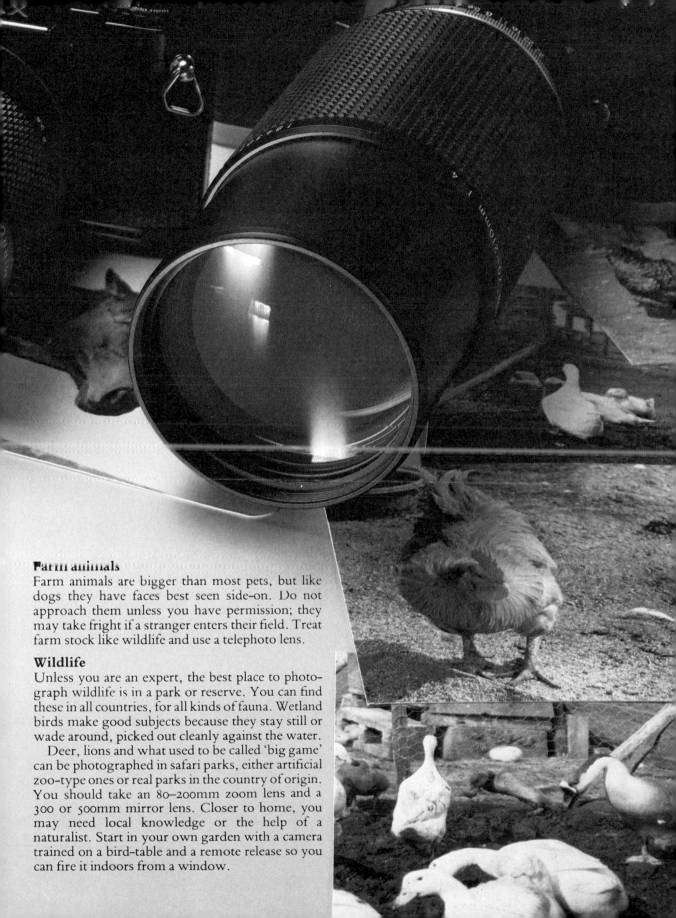

Farm animals

Farm animals are bigger than most pets, but like dogs they have faces best seen side-on. Do not approach them unless you have permission; they may take fright if a stranger enters their field. Treat farm stock like wildlife and use a telephoto lens.

Wildlife

Unless you are an expert, the best place to photograph wildlife is in a park or reserve. You can find these in all countries, for all kinds of fauna. Wetland birds make good subjects because they stay still or wade around, picked out cleanly against the water.

Deer, lions and what used to be called 'big game' can be photographed in safari parks, either artificial zoo-type ones or real parks in the country of origin. You should take an 80–200mm zoom lens and a 300 or 500mm mirror lens. Closer to home, you may need local knowledge or the help of a naturalist. Start in your own garden with a camera trained on a bird-table and a remote release so you can fire it indoors from a window.

HOLIDAYS AND TRAVEL

Leave your camera behind when you travel, and you lose your 'memories' of a trip. Travel can be a day out to the coast, a couple of weeks at a resort or a year spent exploring the world's wild corners.

Picture postcards would be enough to bring back memories if the place was all that mattered. It isn't. Travel pictures and holiday snaps should show how things were when you were there, what you saw, who you met and what the weather was like.

This means the camera has to be with you when all this happens. There is a good argument for taking a compact 35mm camera rather than a complete SLR outfit. What point is there in carrying a case full of lenses with you, only to find that you don't want the encumbrance of equipment spoiling everyday activities?

A compromise is better. If you own a 35mm SLR and have built up an outfit, just take a body, a wide angle, a standard lens and telephoto or zoom. Plenty of film is more important than hardware.

Pocket disc and 110 cameras add very little weight to any travelling case, but the results are not as good as a 35mm compact model. If you attach some value to your holiday shots, why save a little on the cost of a camera when the travel itself costs many time more?

Practical problems

Travellers are often fooled by the apparently 'bright' sun in hot countries. The brightness is partly an illusion; it is also due to very reflective surroundings – whitewashed houses, dusty sand roads, bleached timber and foliage. The sun may be only a little brighter than a summer day back home.

The exposure meter in a camera sees all the light-coloured detail as extra brightness, too, and will tend to cut down exposure. The result is a set of sharp but grey prints. You remember blue seas and bright skies over golden beaches; you get back shots with steely skies, grey seas and murky sand.

To solve this, set the ISO speed setting permanently to half its official value when you are taking pictures on beaches, in desert, in snow, at high altitudes, or in towns with very light buildings.

Heat and dust may cause other problems. Never leave your camera in the sun, or take it on to a beach unprotected. Each night, open the case and carefully blow away any sand using a blower-brush for cleaning cameras. Never wipe or rub the lens.

Above all, avoid salt spray from the sea. If this lands on a lens, it can ruin it permanently. Disc and 110 cameras are worst affected, because their lenses are small and a single drop can blur every picture.

Ethics and religion

It is easy to think that people the world over see your camera the way you do. They don't. Moslems dislike being photographed, and in some parts of the world may restrain careless tourists. Cameras cannot be used freely in Asian or African villages, or in any country with a repressive regime.

Ask locally; a holiday courier will know the rules. In some places tourists are so common that the locals have stopped worrying about religion and just ask for money.

Ethics apply at home, too. Just because a girl sunbathes topless it doesn't mean she wants to be immortalized with a mirror lens from a nearby hiding place. Take pictures openly, making no secret of it, and anyone objecting will make their position clear. Don't sneak shots or photograph subjects asleep. It might amuse you but it gives photography a bad name, and in some countries could mean legal trouble.

Adding interest

Taking these points into consideration, people do add interest to your holiday views. Don't put the same person in front of every landscape. Occasional inclusions of your family or travelling party are enough.

Go one better than having someone looking at a scene. Use action! If there is a market, get a friend to go and bargain at a stall, and photograph the overall scene. Have your human interest eating a local delicacy, sitting with a drink, looking through binoculars, or even photographed taking a picture.

Include signs and street names. It helps you later on, remembering which pictures are which.

Touring by car

None of the world's best photographs can be taken from the open window of a car pulled up by a roadside. For the mobile tourist, the answer is to park and walk whenever an interesting view presents itself.

Cars heat up quickly in the sun. The glove compartment is the worst place to leave film or cameras. Heat destroys the colours on film and damages cameras.

Customs and X-rays

Stories about film damaged by airport X-ray machines are not invented. If your film is X-rayed more than 5 times, it may show signs of fogging (grey veil over the prints, probably with odd shapes outlined). When passing through more than one country, ask for your film to be inspected by hand. Lead foil packs are sold to protect film from X-rays and seem to work well.

CLOSE-UPS

Most cameras do not focus closer than 80cm/ 2ft 6in, because to focus on close distances the lens has to be moved further away from the film. This would mean fitting a long screw thread, increasing expense. Focusing becomes more critical as you get closer; an error of 1cm/½in in a subject 2m/7ft away has little effect, but an error of 1cm/½in in a subject 2cm/¾in away would be disastrous.

A coupled rangefinder or autofocus mechanism cannot be made accurate enough for distances under 80cm/2ft 6in. Apart from the focusing problem, the viewfinder is a few centimetres away from the lens and sees the subject from a different angle. This does not matter when the field of view is a large area a long way off, but a change in viewpoint and field of view at 20cm/8in distance could mean that the two views hardly coincide.

SLR advantages

The SLR comes into its own for close-ups because you see and focus through the lens. This means the view on the film is precisely the same as that through the finder, and the focusing accuracy can be within a millimetre.

Because the lens is removable, any amount of extra extension can be inserted between film and lens for closer focusing. This can take the form of a set of tubes of different lengths, or a variable bellows unit (rather like a vintage camera).

There is a second way of focusing closer – a supplementary or close-up lens, like a weak magnifying glass, can be fixed over the camera lens. This works with viewfinder cameras as well as reflexes, but once again the SLR has the benefit of through-the-lens viewing. Close-up lenses can be slipped in a pocket, unlike bellows or tubes, and cost very little.

Attachments for other cameras

Some makes of rangefinder, 110 and instant camera have close-up devices. They are normally close-up lenses fitted in a special frame which also has a set of supplementary optics for the viewfinder. Prisms and lenses make the finder image as close as possible to the lens image.

The best devices like this have a set of legs, extending in front of the camera. To focus, all you need to do is place the subject in the space between the ends of the legs. For flat subjects like pictures or documents, the camera can stand on the legs.

Using SLR accessories

Zoom lenses often have a so-called 'macro' setting which focuses close without further accessories. This is the easiest way to take close-ups. The expo-

sure will be the same as at normal distances, but you must put the camera on a tripod and use a small aperture like f11 to ensure sharpness. Depth of field is very limited at close distances, often only a centimetre or two.

'Macro' means close-ups where the subject is recorded half life-size, or bigger, on film. The settings on zooms rarely manage this. Nor do close-up lenses; they come in three powers – 1 dioptre, which is for distances around 50cm–1m/20in–3ft, 2 dioptre for 25–50cm/10–20in and 3 dioptre for 15–33cm/6–13in. Like zoom close-up settings they are easy to use, the exposure stays the same, and they cost little.

Extension tubes act in a different way, because taking the lens further away from the film reduces the light reaching the emulsion. At life-size, with a total of 50mm of extension tubes fitted (a full set of 3), only one-quarter of the original light gets through. Instead of 1/125 at f16 in bright sun, you need 1/125 at f8.

Extension tubes keep all the metering and automatic features of the camera, so there are no calculations to do. Results are much sharper than with zooms or close-up lenses. A tripod helps, but handholding is easy.

Bellows units are often not automatic or coupled, though expensive ones retain full camera functions. They allow magnifications beyond life-size, up to ×2 or ×3. The exposure may have to be increased by 3, 4 or 5 steps (either shutter speeds or steps).

Close-up lenses and zooms allow you to photograph small animals, butterflies, flowers, books and objects. Extension tubes cover smaller insects, stamps, coins, jewellery and smaller plants. Bellows are for subjects where you would not see detail without a magnifying glass or pocket microscope.

Focusing

Never try to focus a close-up by setting up the camera and then turning the lens focus; the effect is too small. Instead, move the camera backwards and forwards, or put the subject on a suitable stage and move it instead. You will see it snap into focus as you approach. A special geared rack and pinion rail to hold the camera with tubes or bellows can be bought to fit on your tripod.

Flash

The problems of exposure with tubes and bellows are solved when flash is used. At such close distances, a typical pocket flash needs the lens to be set to f16, taking into account the extension. The electronic flash's high speed eliminates camera shake and subject movement. The best flash units for close-up work are those which couple to the camera to give OTF (off-the-film) metering – there is no need for calculations and every shot comes out perfectly.

Copying

Bellows units take slide copying attachments to hold 35mm slides. Separate close-up tubes with a lens and slide holder can be bought, and are easier to use. For document copying, a rigid copy stand will hold the camera parallel to the original, and lights at 45° on either side (flash or tungsten) give even illumination. The main problems with copy work are even illumination and lining up the camera to avoid distortion; the only adequate solution is a purpose-built stand.

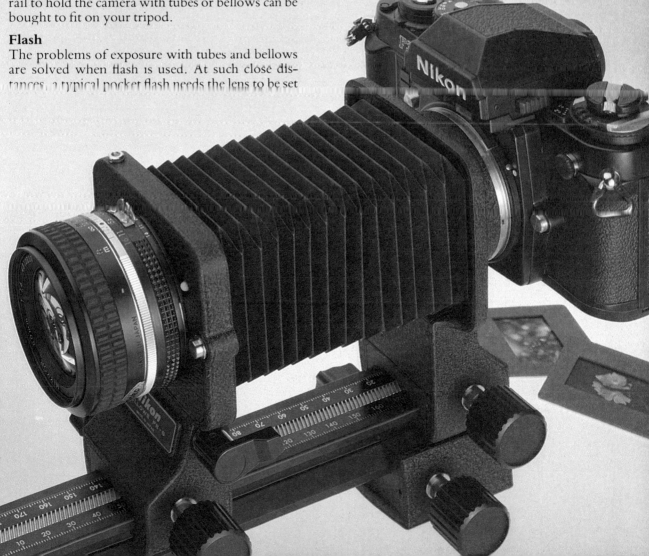

STREETS AND BUILDINGS

It would be difficult to take good pictures of people if you had to lie on the ground and look up at them. That is how a photographer at street-level photographs a building.

Down on the ground, the camera looks up and the building seems to lean backwards and look smaller. The ground floor takes up half the shot and the upper floors get progressively thinner. If there is a bush in the way, it can block half the view. A single street light, a crowd or a derelict car can spoil the shot.

This doesn't mean that ground-level pictures of buildings are all bad. The problems above can be changed into advantages – seeing the building framed by a tree, putting an attractive flowerbed in the foreground, or showing a busy street setting.

Vantage points

In much the same way that mountains look better if you photograph them from halfway up another mountain, buildings look best from a raised vantage point. It could be a rooftop, a window, a balcony or a pedestrian walkway. The ideal height is just below the midpoint; for a 4-storey building, photograph it from the first floor of an adjacent block, rather than the second. Sometimes nothing more than a pair of steps or a wall to stand on will improve a shot of a bungalow or house.

Distance

When there is space, it pays to stand well back from a building. Going further away with a telephoto lens makes it look straighter, more solid and taller. It puts it in perspective with other buildings.

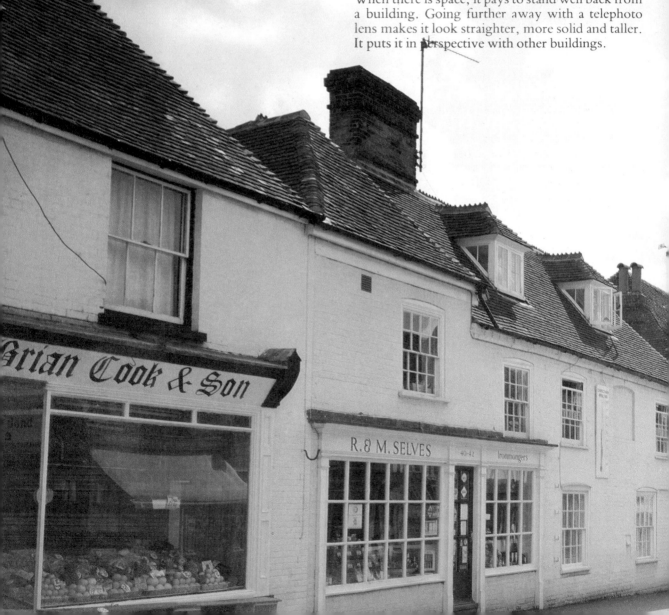

The closer you get the wider angle of lens you have to use, and the more your camera will be aimed upwards. For dramatic effects go very close and use a wide-angle like a 24mm. Be careful to keep the lean on the building balanced so it doesn't seem to fall out of one side of the picture.

With a pocket camera, try a telephoto attachment or slider lens if fitted. The difference, though small, is often worthwhile.

Foregrounds

To keep the building perfectly vertical, the camera must be aimed horizontally. Let's assume you are 1.70m/5ft 7in tall. You are photographing a house, and the viewfinder in your camera has a central focusing spot. Aim the focusing spot at a point 1.60m/5ft 3in up the wall of the building (assuming the ground is level) and your camera will be perfectly parallel. Normally this means aiming just below the top of a doorway or window.

The problem then is that the top of the building is cut off, and the bottom of the picture is filled with unwanted foreground. To include all the building you have to fit a wide-angle and the foreground is increased as well.

Solution? Find a good foreground! Pick part of a flowerbed, street furniture, interesting cobble-stones or something similar, and fill the foreground with this. Alternatively, move further back (angling the camera upwards will then have less effect) or find that high vantage point so you can keep it straight.

Street scenes

Modern streets are wide because of traffic, and if you look straight down the middle, you will just photograph a road with a little bit of detail on each side. Instead stand on one side, and look down the street so that you photograph mainly the opposite side but include just a little detail on the closer side.

The side you shoot should be sunny but it does not really matter if the sun is coming slightly towards the camera. The façades of buildings look better with light skimming across them.

If the light is off the side you are interested in, move closer in so that the sky is cut out of the shot, or come back at a different time of day. It is worth waiting for the sun to go behind a cloud rather than put up with a shot where the buildings are in shade and the road in bright sun.

Winter and early morning or evenings are times to avoid. Buildings are often half-lit, with the shadows of the opposite row cast on them. Film cannot cope with the difference and the results are normally failures.

City centre streets look good in snow, because all the detail of services and utilities is covered, and the original plan remains. This is particularly true with historic streets; hydrants, modern paving, litter-bins and so on are covered with timeless snow.

Night-time has similar advantages, with unwanted details disappearing into the shadows, and street lights adding a touch of colour. With a very long exposure cars and people disappear as they do not stay still long enough to record on the film sharply.

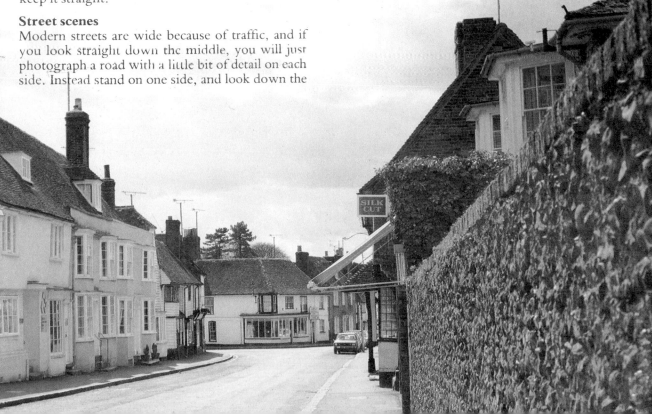

GROUPS

Every gathering of friends or relations is an opportunity for a group picture. On rare occasions you can take a valuable record, perhaps a shot with relatives from overseas or all the members of several generations of a family.

Successful group pictures need organizing ability as well as photo skills. Unless you know what you are doing, you cannot speak authoritatively and get people to do what you want. If you know exactly what the final result should look like, you can say exactly where you want each person to stand.

Though heights differ, most people's faces are roughly on the same level when they stand in a line. This means that the vital interest in the picture ends up occupying a thin ribbon across the frame, with lots of body and leg below.

If people do not stand in a line, they have to be in front of or behind each other, and this produces a subject with extra depth. As you know, sharpness in a deep subject depends on the aperture setting and depth of field, and flash falls off with distance. These two factors may mean some faces being out of focus, or some being lighter or darker than others.

Serious problems can be avoided if you limit any group to 3 people deep; a main row, a back row visible between their heads, and a front row kneeling, sitting or squatting below.

Posing a group

With 3 or 4 people a single line is acceptable. Leave a little space either end on a 35mm shot, because the colour print is not the same shape as the viewfinder and some will be cut off. Rather than a straight line, ask your group to make a slight semi-circle, concave towards the camera. Put the taller people at the outside if there are 2: if there is 1 taller member, put him/her centrally or as one of the centre two.

Five people can be posed with a group of 3 as a back row and 2 sitting or half-kneeling at the front. You miss off the bottom half of the view, so you do not see they are kneeling.

A group of 6 or 7 can be posed in a similar way. For more than 7, start building a third row behind, looking through the gaps. If you can get a low bench for them to stand on (or use a convenient grass bank or step) it helps.

Children naturally stand in front. Sometimes, a full-length group can be shot with adults bobbing down to hold small children. This is a good way of including younger retainers at a wedding.

Once you get to the size of a football team, more formality is needed unless you want a shambles. The front row can all kneel identically, the same knee forward, or sit. The main row should be dead straight, all hands held the same way. A back row echoes this, and spare tall members can stand at each end, angled slightly inwards, to 'hold the group together'.

Flash

Direct on-camera flash is not flattering and can produce 'red eye'. With groups, you must not use flash unless a good bounce ceiling is available. Any attempt to move the flash off the camera to one side may make shadows from one line fall on the next row of people.

This happens even when you use one of the special card diffusers supplied with many flash-guns. If the gun is mounted on a bracket next to the camera, with a card bouncer on a clip, the light may be soft but the shadows are still well-defined and directional. Play safe and use the flash as close to the lens as possible, and directly above it rather than slightly to one side. Then all the faces in the group will be cleanly lit.

Even lighting in depth depends on the relationship between camera to group, and the group depth. If a group made up of 3 rows is 1m/3ft deep in total, and the camera is 2m/7ft away, there will be about half as much light reaching the back row as the front. This can happen with wide-angle lenses. When the room permits, move back and use your standard lens or even a tele zoom on around 80mm. From 4m/13ft away, the difference between back and front row will be only half a stop, small enough to make no difference.

Electronic flash is unkind to red faces. They come out darker than you expect. Remember to put suntanned or rubicund parties in the front row (most light) and not the back!

Treat black suits and white dresses the same way. Wedding photographers taking a picture of the bride and groom by flash ask the bride to stand further from the camera, the groom nearer. The dark suit receives more light than the white dress, and this helps even out the difference. The only snag is that men also tend to be larger than women, and putting them nearer the camera emphasizes this too.

Feet and hands

Cardinal sins in group pictures include the classic line-up with everything included except feet – right down to the ankles. This looks terrible. As with a portrait shot, cut off just above the knee, never between the knee and foot.

Hands have to be organized. The same pose in every member of a group increases formality. Ask 2 people to hold their hands joined in front of them, another 2 to have one hand in a pocket and the other loose, another to have hands behind him/her, and another to rest one hand on the back of a chair. Avoid crossed arms, clenched fists, and both arms hanging down in a limp version of 'standing to attention'!

Anything held helps – evening bags, a cigar, a drink if there is no objection, a bouquet, a toy for a child, a trophy.

Finally, take several shots. In any group, pure chance will mean some people blinking or grimacing in each shot. The way to get one reasonable overall picture is to overshoot.

SPECIAL CAMERAS

Most cameras are made to work well under a whole range of conditions without elaborate accessories, but some cameras are made for special purposes.

The most useful special cameras for amateurs are the rugged, waterproof models sold for outdoor sports and holidays. There is no need to spend a fortune on the all-weather Nikonos IV, which is intended for scuba diving and has interchangeable lenses. Pocket 110 cameras like the Minolta Weathermatic are just as at home in a canoe, on the beach, in snow, cycling, or in a swimming pool.

The advantages of the 35mm format are found in Fujica's HD cameras, or by choosing a 35mm micro compact from a maker like Ricoh or Cosina which has an optional perspex all-weather and underwater housing. These cameras and housings are also very good in cold conditions when you want to wear gloves, because they have oversized controls to make underwater operation easy.

All-weather cameras are sealed against rain but can still be damaged by sandstorms or dust, especially if the film has to be changed. The rubber O-ring seals which keep the water out may no longer work if sand gets in. On the whole, they also resist knocks and rough handling. 110 format models have the additional advantage of low cost.

Subminiature cameras

There are film sizes even smaller than 110 or disc, called subminiature. The most popular make, with film and processing readily available by mail order, is Minox. This German 'spy camera' takes slides or negatives only 8 × 11mm in size. The results are good because of the exceptional precision of the camera and the great care taken in processing.

Special 35mm cameras

A 35mm camera does not have to take a picture exactly 24 × 36mm like most popular models. Half-frame cameras are available, like the Olympus Pen EE–F, which can take up to 72 pictures 18 × 24mm on a roll of film. Some cameras have a square 24 × 24mm format but this is very rare.

Panoramic cameras can take a negative up to 58 × 24mm and use a lens with a clockwork motor which swings round, covering the film held in a curved track.

Some 35mm SLRs can be bought modified for different uses. For many years the Russian camera industry has made a kit called a 'Photo Sniper' outfit with a special 35mm SLR body fitted to a rapid focusing super-telephoto lens on a rifle stock. Nikon make a camera with a titanium body and a built-in motor drive taking 10 shots per second.

The Leica M system is a range of 35mm cameras and lenses, but instead of being an SLR the M has a rangefinder with suspended frames visible for each lens fitted. As there is no mirror, the noise when firing is minimal. The Leica is used for its quietness, precision, optical quality and exceptional reliability. The Minolta CLE is a compact electronic version, made through co-operation with Leica, with its own range of 3 compatible lenses.

Professional cameras

Film sizes larger than 35mm are mainly for professional use. The 120 rollfilm size, which can be used for pictures from anything between 6 × 4.5cm/2¼ × 1¾in and 6 × 9cm/2¼ × 3½in, is the most popular.

Box-shaped cameras with 2 lenses one above the other, and a hood to look down into at waist-level to view the picture, are called twin-lens reflexes. The Mamiyaflex C system uses interchangeable pairs of lenses. The upper lens forms an image via a mirror and screen, like an SLR, and the lower lens matches this with an image on the film. As there is no moving mirror, the cameras have much simpler mechanisms and are very quiet.

Folding cameras are rare, but 2 models are made by Plaubel in Germany using Japanese lenses. Although they have a very large film size of 6 × 7cm, they collapse with bellows and lazy-tongs to fit into a pocket. One is 'normal' and the other 'wide angle'. Like most rollfilm cameras they cost much more than the best 35mm models.

The most popular rollfilm cameras are SLRs, like 35mm SLRs but much larger. To fit the hand better, most of them have waist-level viewing screens which you look down into, and a box shape instead of a 35mm-SLR shape. The best known is the Hasselblad. Mamiya's RZ is fully electronic, in contrast to the Hasselblad's Swedish mechanical design. Pentax make an oversized version of the eye-level 35mm SLR, called the Pentax 6×7 because it takes ten 6 × 7cm shots on a roll of 120.

Even larger film sizes are used in professional studios. The most popular format (as with other makes) is 9 × 12cm or 5 × 4in. Film for this size is cut into individual sheets and loaded into sheaths called darkslides. For each shot, a darkslide is put into the camera. Cameras like this have a ground-glass screen on the back and the image from the lens, reversed laterally and upside down, is focused with magnifier and composed under a dark cloth.

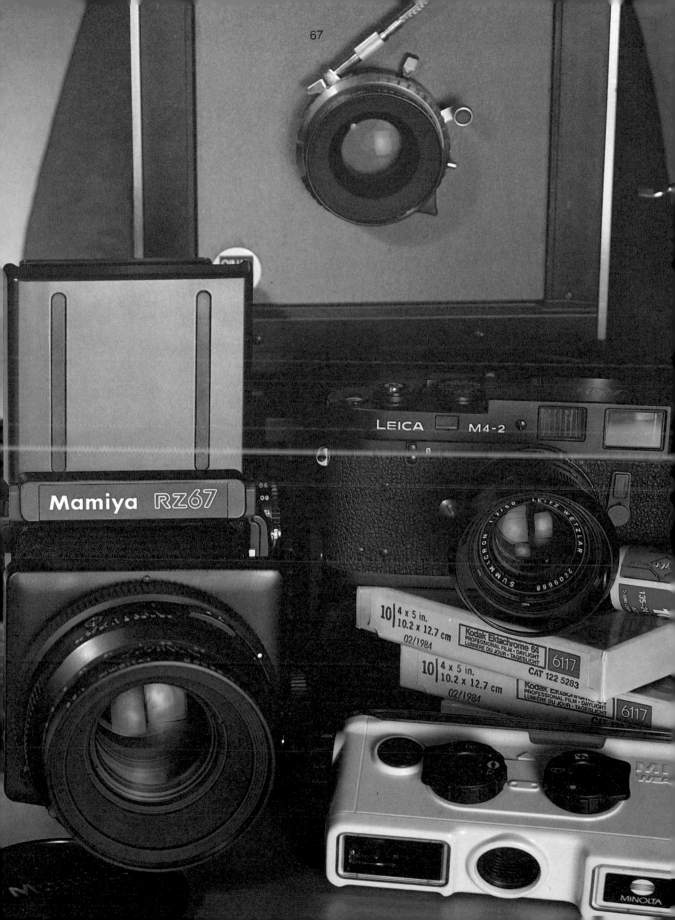

HOME PROCESSING

Processing or printing your own films at home is an enjoyable hobby and can add a new dimension of creative control to your photography. It is really a separate hobby from photography itself. Perhaps one of your family enjoys taking pictures but would not like to spend an evening printing them. Someone else may find the processing and printing engrossing without much enthusiasm for picture-taking.

What do you need?

There is no point in trying to handle any kind of photo processing if other people in the house are going to find it very inconvenient. You need to take over an area with a worktop, heating, a water supply, and freedom from interruptions for 30 minutes to an hour.

The best places for processing are a utility room with a sink, or a spare bedroom with a basin. A garage or garden shed with water supply, electricity and heating can also be used. If the room can be blacked out totally, all the better. There are special 'tents' available so that you can make prints in a room which cannot be blacked out.

The least convenient choices are the kitchen or bathroom; both have the water supply needed, and the kitchen also has worktops and electricity. The bath can be fitted with a worktop, but electricity has to be brought through with a cable. If you only have one WC, then occupying the bathroom is anti-social.

If you want to process film, the freedom from interruptions and the need to black out a room is less important. Use a lightproof bag called a changing bag to load the film into a lightproof developing tank. You then work in ordinary room lighting. You need to be able to put the film tank under a running tap for 30 minutes, but you can take it to any convenient tap. Finally, you need a dust-free place to hang the film up to dry where people will not continually be walking in and out. The hook to hang the filmclip on should be 2m/7ft above the ground (e.g. on a low ceiling or a door-frame top) and at least 30cm/12in from the nearest wall. Drying takes about 2 hours.

The kit

Our photograph shows a popular colour home darkroom kit which costs about the same as a medium-priced 35mm SLR camera with standard lens. For this, you get a colour enlarger of a simple but reliable design, processing tanks for film and paper, chemicals for both, thermometers, measuring jugs, frames to hold the paper under the enlarger, and some printing paper. All the film clips and small extras you might forget to buy are included.

Timing and temperature are both important in photo processing. Hot and cold water supplies, and a fan heater to keep the room warm, are necessary. A watch with accurate minutes and seconds will do for most timing, but a laboratory timer is easier to see.

For film processing a small bench area or the draining board of a kitchen sink is all the space needed. Making prints using the enlarger calls for a little more space – about 1.5m/5ft of normal work-top at the minimum, though this can split into 2 areas, one for the enlarger and paper ('dry' bench) and one for the processor and chemicals ('wet' bench).

Colour prints can be made in 2 rooms, because the processing is done in daylight once you have loaded the processing tray or drum. Your enlarger can be under the stairs in a blacked-out storage cupboard, and to process each print you can work in the kitchen.

Black and white or colour?

Black and white prints are easier to make than colour, because the only variable factors are the contrast (paper grade) and the exposure (darker or lighter prints). You process black and white paper by the light of a red or amber 'safelight' in open dishes of chemicals, and you can see the image form getting darker.

Apart from the thrill of seeing your prints develop, and being able to judge the right moment to end development, the material cost is low and the chemicals relatively harmless as well as easy to mix, store and use. Black and white is processed at low temperatures, around 20°C/68°F, roughly room temperature.

Colour printing from slides is also fairly easy, because you can see the right colours in the slide and use the colour filter controls on your enlarger to match the print to them. The chemicals and paper are much more expensive, and a well-ventilated room is needed.

Prints from colour negatives are not so simple; it is hard to judge the correct colours, and the negative gives no clues. Every type of film needs different settings on the enlarger. You need experience before your prints are much good. An electronic colour analyser and timer, which judges the negatives for you and helps you set the enlarger correctly, is almost essential.

Simple processes

Paying a little more for materials, you can use some simple 'instant' processes which do not need elaborate temperature or timing controls. Agfa-chrome Speed is for prints from slides and uses no special equipment. The paper is soaked in a single long-lasting alkaline solution for 90 seconds, then washed for 6 minutes in running water, in daylight. The image gradually appears.

Kodak Ektaflex uses 2 sheets of paper – one is exposed and soaked in a low-cost long-lasting solution, then squeezed onto the other sheet with rubber rollers. A processor is needed for this. The room light can be turned on, and after 7–14 minutes the sheets are peeled apart and you have a nearly dry print from a slide or negative with no futher wash-ing or processing needed.

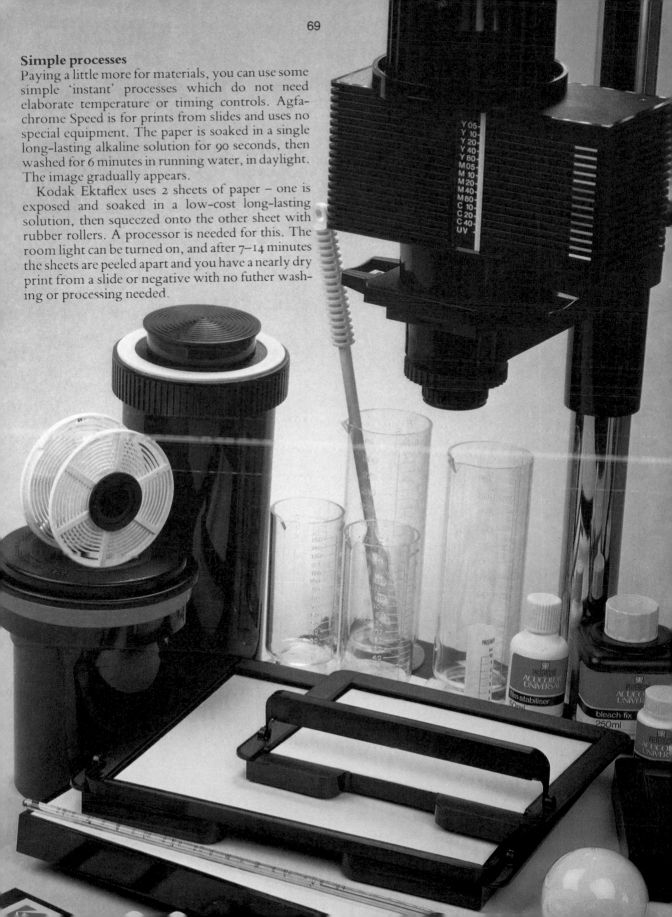

STORING AND FRAMING

Photographs are valuable records, like letters. Even ordinary family snapshots from the last century are treasured today, all the more so if the owner has some idea of their origin. Far too many of them are just 'old photographs', from forgotten family albums.

Storing your pictures the right way can make it much easier to look after them and refer to them, even when you move house or want to go back many years through your photo-files.

Negatives

Negatives are the master original for all your prints. Give prints away to people, but never let them borrow a negative! If it is never returned, you lose it for good. As negatives are cut into strips of 4 or 6 frames, more than just one shot is lost.

Negatives should be stored in acid-free envelopes. The protective folders supplied when you have them developed are correctly designed, but for a tidier system you can buy ring binders which take sheets to hold whole films on a single page.

Contact sheets are special prints, made from the whole film on a single sheet of paper, the same scale as the original negative. Though not big enough to look at, each shot is clearly recognizable and you

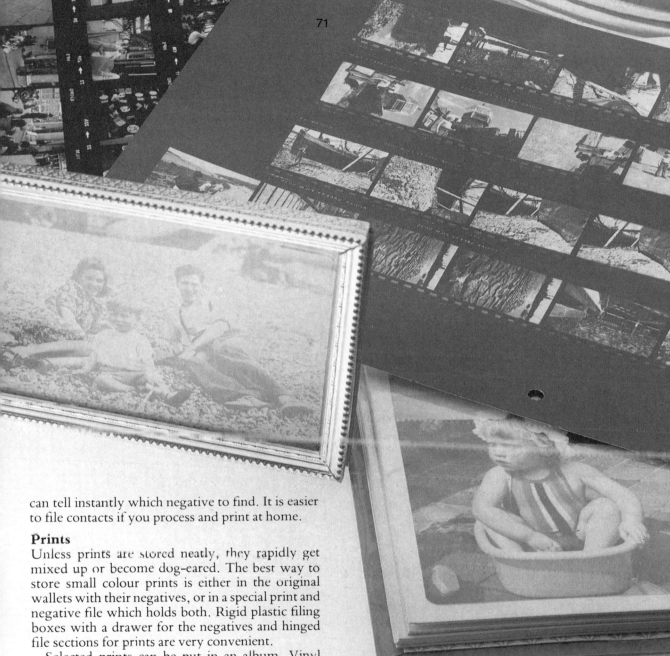

can tell instantly which negative to find. It is easier to file contacts if you process and print at home.

Prints

Unless prints are stored neatly, they rapidly get mixed up or become dog-eared. The best way to store small colour prints is either in the original wallets with their negatives, or in a special print and negative file which holds both. Rigid plastic filing boxes with a drawer for the negatives and hinged file sections for prints are very convenient.

Selected prints can be put in an album. Vinyl wallet-size albums with from 12 to 48 leaves, to fit enprints 8 × 12cm/3 × 5in, need no adhesive. Nor do larger albums with 'magic mount' leaves: you lift a plastic skin, place the print on the page, and smooth the skin down again to hold and protect it. Several small prints can be put on each large page.

Always write the date, place and subject on the back of your prints. Memories are unreliable! Ten years later, which baby was it? And which year?

For display, prints can be put in an ordinary picture frame. They are made in the same sizes as prints. Card or block mounting, undertaken by framers, art shops and photographic studios needs no glass and looks much cleaner.

Most good pictures look even better if you have an enlargement 20 × 25cm/8 × 10in made. Frame or mount the picture and hang it where visitors can see it. Your decor at home might as well be your own work!

Some shops and mail order firms make very big prints, up to 75 × 100cm/30 × 40in, from 35mm negatives or slides. They are surprisingly good and do not cost much. Display them by taping a 1-cm/½-in diameter wooden dowel to the top and the bottom, and hanging them like a poster or Japanese bamboo painted screen.

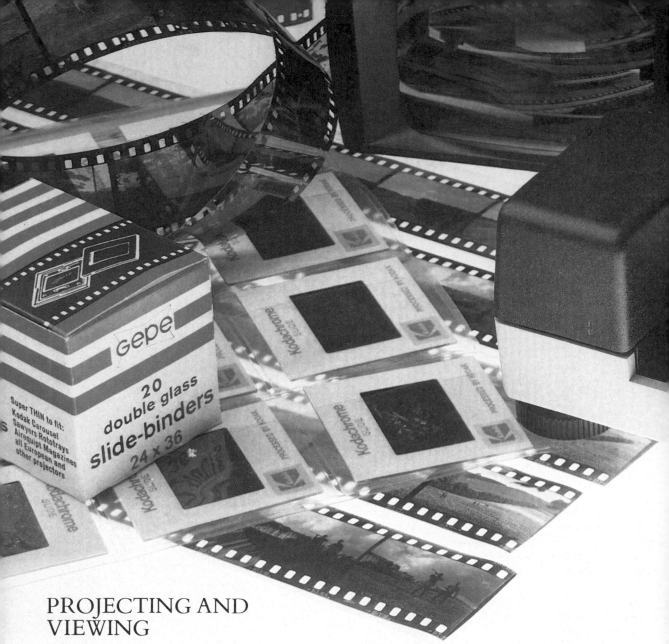

PROJECTING AND VIEWING

There are three ways of storing slides – ready to view but not to project, ready to project but not to view, and ready for neither! Sheets which hold 35mm slides on suspension filing bars or in ring binders let you look at 20 to 24 slides at a time, holding the sheet up to the light. Special viewer-holders take 12 slides and have a sliding magnifier. Some wallets for posting slides use the same kind of system, with every slide visible in front of a light-diffusing backing.

Magazines for projection generally hold the slides upside down in a tray with from 35 to 100 slots in a straight line, or up to 140 in a circular form. You can store the tray in a dustproof stackable filing case, but to see a slide, you must either know which number it is and pull it out, or put the entire magazine into a projector and find it by showing the slides.

The boxes which slides come back in from processing are the cheapest form of storage. They also take up least space. You cannot view a slide without removing a whole section and sorting through.

There are some projectors and table-top viewers which accept a loose stack of slides, as shown here, and feed them through automatically. If you have one of these, slide boxes may be very satisfactory for storage. The problem with slides is their size, which means they must be magnified or projected for viewing, and makes any 'filing sheet' system for quick reference only.

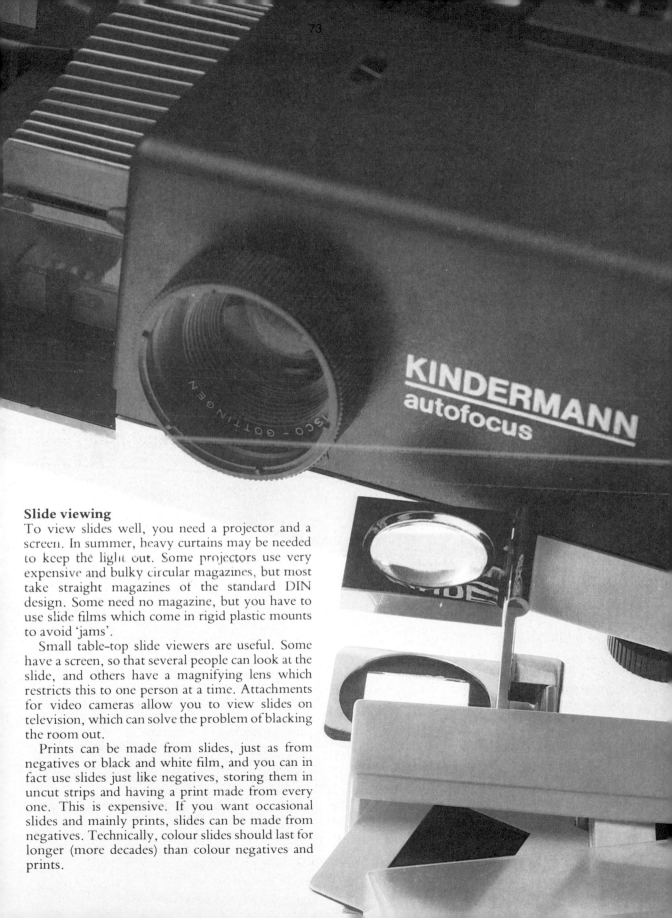

Slide viewing

To view slides well, you need a projector and a screen. In summer, heavy curtains may be needed to keep the light out. Some projectors use very expensive and bulky circular magazines, but most take straight magazines of the standard DIN design. Some need no magazine, but you have to use slide films which come in rigid plastic mounts to avoid 'jams'.

Small table-top slide viewers are useful. Some have a screen, so that several people can look at the slide, and others have a magnifying lens which restricts this to one person at a time. Attachments for video cameras allow you to view slides on television, which can solve the problem of blacking the room out.

Prints can be made from slides, just as from negatives or black and white film, and you can in fact use slides just like negatives, storing them in uncut strips and having a print made from every one. This is expensive. If you want occasional slides and mainly prints, slides can be made from negatives. Technically, colour slides should last for longer (more decades) than colour negatives and prints.

PICTURE PROBLEMS I

Serious camera shake is a result of a long shutter opening time when you needed flash or a tripod. You can spot it by the directional or multiple imaged blur, rather than the soft smooth blur from bad focusing. The cure is to use flash, a faster film or a tripod. With overexposure, it may show a camera fault.

Blurred moving subjects in a sharp scene happen because you used a shutter speed too slow to freeze the action and didn't 'pan' with the subject. It is not a camera fault. The blur always has a directional movement. The solution is to follow the subject with the camera if you cannot use a fast speed.

Do not complain if the last shot on your film comes out like this, cut in half or with marks from clips used in processing. You buy a roll for 12, 24 or 36 exposures and if you take any 'extra' shots (often possible) the last one may be so close to the film end that it is cut off or damaged.

The light-coloured bands across this transparency are caused by handling the 35mm film cassette in bright light before or after use. A small amount of light gets through the light-trap and 'fogs' the first one or two frames. Keep cassettes in lightproof containers, and load or unload in subdued light.

Out of focus: this kind of picture is hard to take with an SLR camera because you see it through the finder. With 110, disc, instant or autofocus 35mm cameras it is caused by being too close. Viewfinder and rangefinder cameras always show a sharp finder image, and you can forget to focus the lens.

Computer flash failure: although within the range of distances for automatic flash, this picture shows the sensor eye of the flash aimed at the background scene, and exposed correctly for it, ignoring the real subject of people at the sides of the shot. For compositions like this, only use manually set flash.

This is the camera shop salesman's favourite joke! Every dealer knows a customer who took a whole roll like this. It is the result you get when you look the wrong way through a pocket camera view-finder, and have the lens aiming at your right ear instead of the intended scene. This is easier than you think.

Completely clear slide film or totally black negatives can only result from severe exposure to light, either by a shutter staying open for a very long time (like 1 second) in sunlight, or the camera being opened. If part of a roll is blank like this, with some frames half-damaged, this is probably the reason.

Completely unexposed film: the shutter has not opened, the film was never transported, or you left the lens cap on (not possible with an SLR). An entire roll blank usually means faulty loading, especially if the first frame is white. When using flash, blank frames result from the wrong shutter speed or cable connection.

Underexposure: in colour, prints do not look black, but grey and grainy instead. This is a result of too little light reaching the film. Slides look very dark (not grey) and black and white negatives are thin and clear. Check that you have set the correct ISO film speed – the most common cause is setting 400 instead of 100.

Overexposure: a light, contrasty or washed-out picture, lacking in skin tones and with blue sky shown too white, is a result of overexposure. Slides look very pale, prints harsh, and negatives very black. Common reasons include using flash too close and leaving meters set to ISO 100 with ISO 400 film.

This underexposure, making snow seem grey, happens because the overall scene is very light and the meter assumes it is a view with normal subjects like grass or rocks, brightly lit. The answer is to increase exposure by 1–2 steps for snow, light sandy beaches or water. The lighter the subject the more correction needed.

PICTURE PROBLEMS II

Electronic flash lasts for 1/1000th of a second or less, but the shutter speed to synchronize it may be 1/60. If there is bright detail behind the subject, and either the camera or subject moves rapidly, the bright background can overlap the subject and make part of it 'ghost' or seem transparent.

Ordinary domestic light-bulbs are much yellower than daylight, and colour pictures taken indoors without flash can look brown, yellow or orange. Sometimes this looks right, as in a fireside scene. To correct the cast, a blue filter called an 80B can be bought. Filters are not needed with colour *print* film – only for slides.

Fluorescent tubes look similar to daylight in quality to the eye, but in fact they have too much green and too little red in their light. Colour pictures taken in fluorescent lighting look like this, with a strong unpleasant green hue. A correction filter called an 'FL-Day' can be bought to solve the problem.

Filters made of coloured glass or plastic can be used with black and white films to change the way different colours record as shades of grey. You must remember never to leave one of these on the camera if you change from black and white to colour, or swap a lens from one camera to another. In colour the result is an overall cast.

Using a wide-angle lens very close to the subject can mean that the flashgun on top of your camera is too high up. It lights the top half of the subject but misses out the bottom. Unlike wrong X-synch speed setting, the edge of the dark area is not a sharp line. Always use a wide-angle flash diffuser if supplied.

Computer flashguns with swivel and tilt bounce heads may have 2 or 3 'auto' aperture f-stop choices. You must always use the widest (smallest numerically) f-stop for bounce flash. If you don't, the shot will be underexposed. This is also the result you get if the flash sensor cell is aimed at the bounce surface.

Even with an SLR (viewing through the lens) you may fail to spot a finger or strap very close to the front glass. Be careful. With a viewfinder camera of any type, there is more risk. When the same obstruction appears in every shot, first check where the case or strap naturally hangs, then check the inside of the camera.

The focal plane shutter of any SLR camera has to uncover the film completely for synchronization with flash. Most shutters only do this at speeds of 1/60 or longer. If you set a faster shutter speed than the X-synch speed, only part of the frame will be uncovered when the flash fires. The black part always has a very sharp edge.

Underexposure due to a bright sky included in the shot can only be avoided by composing to cut out the sky, or metering with the camera angled down at the ground and holding the reading while re-composing. Some cameras have exposure override for situations like this. Remember how bright the sky is compared to the ground.

Timing is important, and so is follow-through, when you pan to catch a moving subject. The shutter must be fired just before the point you want to catch. Failure to keep the camera moving, and follow through, means missing the subject or cutting part of it off even if you have the timing right.

Most cameras have interlocks which prevent double exposure. This picture is a result of taking 2 shots on the same frame of film accidentally. This can happen if you move a double-exposure control by mistake (when one is fitted) or accidentally press the 'rewind' button on the base of the camera, then wind on again.

Occasionally, pressing the rewind button by mistake causes 2 frames to overlap like this. A film advance fault can also be the cause. If a whole roll of film looks like this, you have probably re-loaded a used 35mm film. To avoid this, wind the film right back into the cassette or tear the film leader off after unloading.

GLOSSARY

AE A term used to describe automatic exposure normally when the shutter speed is set automatically after the aperture is set manually.

AE Lock A button which locks automatically set exposure, allowing the user some control.

Aperture (see f-stop) The part of a camera lens which can be adjusted to form different sizes of hole, and admit more or less light as required. A small (narrow diameter) lens aperture gives a dim image reaching the film, a large one a bright image.

Aperture Priority See 'AE'.

ASA See Film Speed.

Autofocus Any system which sets the focusing by sensing the distance from camera to subject when you press the shutter.

Autowinder Any motorized film advance system which operates at two shots per second or slower.

B When marked on a shutter speed control, usually next to 1 (one second), B is a setting where the shutter will stay open as long as the shutter release is kept depressed. B stands for Brief Time.

Backlight See *Contre Jour*.

BC An abbreviation which normally stands for 'Battery Check', found on many cameras, flashguns and other equipment.

Bellows (a) In older cameras, used between lens and body to allow folding action. (b) In modern SLRs, fitted between lens and body to allow extremely close focusing down to almost microscope-power magnifications.

Bounce Flash A method for obtaining soft even lighting by aiming the flash at a nearby light-coloured surface like a white ceiling, instead of directly at the subject. When mentioned in the specification for a flashgun, the term means a swivelling or tilting action of the flash head to allow this.

Cable Release A short mechanical or electrical cable which attaches to the camera, and allows shake-free release of the shutter especially when the camera is mounted on a tripod.

Camera Shake Unsharpness caused by the camera moving during the actual exposure, especially when the shutter is open for times longer than 1/30th without a tripod.

Chrome Term popularly used in Japan and USA to describe colour slide films.

Computer Flash Obsolete term for automatic flash exposure when carried out by a sensor on the flashgun, rather than through the camera lens.

Contre Jour Conditions where the main light direction comes towards the camera from behind the subject, rather than from behind the photographer.

Data Back A special accessory fitting some cameras which allows you to print the date, time or other details like a serial number on the photo itself.

Dedicated Flash Any form of flashgun which couples through to the camera's controls when fitted, and adjusts settings automatically. Dedicated flashguns often fit one camera make only.

Delayed Action See Self Timer.

Depth of Field At any given focus setting and f-stop, the amount of subject depth which will be apparently sharp in the final picture. Scales or guides are provided to help show this on many cameras. See Focusing, Focus.

DIN See Film Speed.

EE A term for automatic exposure on cameras where the lens aperture (f-stop) is set automatically after the shutter has been set manually.

Exposure (a) A picture or the act of taking one – 'I will make another exposure', 'the last exposure on the film', etc. (b) The degree of light reaching the film, or the control settings needed to get the correct result – 'too much exposure', 'under-exposed', 'an exposure of 1/125 at f8', and so on.

Extension Tube A tube which fits between the lens and body on interchangeable lens cameras, in order to allow focusing at very close distances, often down to 10cm/4in.

f-stop Any marked setting on a scale used to control the lens aperture. The f-stop figure is the diameter of the lens aperture divided into the lens focal length. The normal f-stop figures are a series running f1.4, f2, f2.8, f4, f5.6, f8, f11, f16, f22, f32. On equipment, the 'f' is missed out and only the figure marked.

Film Speed The fixed sensitivity of a film to light, expressed as a number. There are three popular terms: ASA (obsolete) with a scale in which doubling the number doubles the light sensitivity (e.g. 25 ASA, 50 ASA, 100 ASA); and DIN (obsolete) where an increase of 3 in the number doubles sensitivity (15° DIN, 18° DIN, 21° DIN). The current term is ISO, replacing the other two terms and including both numbers – ISO 25/15°, ISO 50/18°, ISO 100/21°. ISO speeds can be set on the scales marked ASA or DIN on older cameras.

Filter A glass or plastic optical sheet which is coloured or otherwise treated to alter the appearance of a picture when placed over the camera lens. Some filters are purely corrective and intended to cut haze or deepen sky colours; others are creative and intended to alter colours or sharpness.

Filter Thread The fine threaded rim at the front of many camera lenses, which is intended to accept circular threaded filters or adaptors to fit others. Sizes may range from 39mm diameter to 72mm on popular cameras.

Fisheye A lens which takes in a field of view around 180° diagonally and gives everything a curved or bulging appearance.

Flare Degrading of the picture contrast by stray light – may resemble patchy mist or strings of coloured light shapes.

Flash Check A light or audio warning which sounds when an automatic flash system has given the correct exposure. Sometimes, a separate button which can be pressed to fire a flash and find out if this will be the case.

Focal Plane The position where the film is held in the camera.

Focus Check Any electronic system built in to a camera which gives an indication, usually by signal lights, when the focus setting is correct.

Focusing, Focus Camera lenses are only capable in theory of focusing one distance sharply at a time. You cannot have 1m/3ft and 5m/15ft focused simultaneously. In fact there is some latitude, and a general zone of sharpness surrounds a focused point. Focusing scales on lenses are marked in metres or feet and should be set before a picture is taken. Some cameras have switches or scales with simple symbols.

Format The size of film used, usually expressed as a number – 35mm, 110, 6×6, etc.

Hot Shoe An accessory shoe on the camera top which will accept a flashgun, and fire the flash without any need for an extra linking cable, as the contacts are built-in to the shoe.

ISO See Film Speed.

Lens Mount The flange which joins the lens to the camera body in cameras where the lens can be removed. There are several different kinds of lens mount and they are not compatible.

Lens-cap A clip-in or push-on cover to keep the camera lens protected when being carried or stored (do not confuse with lens hood).

Lens Hood A shade which attaches to the filter thread of a camera lens, to stop stray direct sun from interfering with the picture.

Macro A general term for photography of small subjects needing very close focusing, resulting

in an image larger than half life-size on the film.

Manual Any adjustment which is not automatic, usually referring to the option to set shutter speeds rather than let the camera set them. May also refer to manual focusing, manual film-wind, and so on.

Mirror Lens A special kind of very light, compact telephoto lens mainly suitable for wildlife and sports or news photography.

Mode In cameras, a choice which can be made by the user to select a different way of metering exposure, as in shutter priority mode, programmed mode, flash mode, where a camera offers a range of alternative methods.

Monochrome Black and white.

Motor Drive Any motorized film advance system which operates at faster than two shots per second, normally with continuous shooting as long as your finger remains on the shutter release.

Negative Film original with the tones and/or colours reversed, for making prints (not to be confused with slides).

Nicads Rechargeable dry batteries, recommended for low long term cost with flashguns. Nickel Cadmium cells.

OTF Off the film – referring to metering systems where the light is actually read from the surface of the film during the exposure. Normally applies to flash exposure only.

Override Any control which locks or resets the automatic functions of a camera so that the user can change the result (e.g. full manual override, pictorial override control, etc.).

Programmed, Program A type of automatic exposure where the user

does not have to set any controls, as both shutter and aperture are adjusted according to a program built in to the camera's circuitry.

Rangefinder A special aid, usually built in to a viewfinder system (see Viewfinder) which helps you ensure that the lens is correctly focused (see Focusing).

Recycling With electronic flash, the short period after taking a shot which the flash needs to charge up its capacitors before the next shot can be taken.

Remote Control A device for firing the camera shutter without a connecting lead; normally radio, sonic or infra-red.

Reversal Any process which results in a slide or makes a print from a slide, rather than involving a negative.

Rewind Some cameras need the film to be wound back into its cassette after the last frame. This only normally applies to 35mm cameras; cartridge, disc and rollfilm cameras do not need winding back.

Self Timer A timing device in the camera which can be set to delay shutter release for a short period after pressing the shutter, e.g. 10 seconds, and allow the photographer to appear in the picture.

Shutter Priority See 'EE'.

Shutter Speed The time duration of shutter opening – how long, in seconds or as a fraction of a second, the shutter is open to allow light to reach the film. Normally marked as a number rather than a fraction, so '125' on a shutter speed control is equal to 1/125th of a second.

Slide Colour transparency, for projection.

Slow-speed Warning An audio signal in automatic cameras which

tells the user to fit flash or use a tripod, because the shutter speed will be too long to hand hold without camera shake.

Stop-down Preview A device found on some single-lens reflexes which lets you see through the lens at the same aperture the photograph will be taken at, and assess the result more accurately.

Telephoto, Long Focus Any angle of lens view narrower than 40° diagonally. On a 35mm SLR, any lens longer than 65mm focal length.

Tripod Bush A threaded hole in the underside of a camera which allows it to be fixed to a tripod or clamp.

TTL Through the lens – normally referring to exposure metering carried out through the camera's own lens.

Viewfinder Any part of a camera which you look through to aim the camera and see the area of the scene which will be included on the final picture.

Wide-angle Any angle of lens view wider than 50° diagonally. On a 35mm SLR, any lens shorter than 40mm focal length

Wind-on, Advance Both these terms mean moving on to fresh film after the last shot has been taken. Hence cameras may have 'auto-wind', 'thumb wind', a 'wind-on lever' or 'motorized advance'.

X, X-sync An abbreviation for the setting needed for electronic flash which does not use expendable flashbulbs, bars or other disposable light sources.

Zoom Any lens which has a variable angle of view, so that the scene covered can be altered without changing the camera viewpoint.

ACKNOWLEDGEMENTS

We would like to thank:

The Leeds Camera Centre, 16 The Brunswick Centre, Bernard Street, London WC1. **Studio 137,** 137 High Street, Sheerness, Kent. **Minolta (UK) Limited,** 1–3 Tanners Drive, Blakelands North, Milton Keynes. **Kodak Limited,** Kodak House, Station Road, Hemel Hempstead, Herts. **Paterson Products Limited,** Photographic Equipment Manufacturers, 2 Boswell Court, London WC1.

Also:

Chris Laing, Gail and Lucy Duff, Maggie, Sophie and John Wire, Valerie and Duncan Clarke, Doris and Vic Morris, The Royal Oak, Charing, Richard and Martin Horne, Paul McIntyre, Anne Coffey, Wendy Ennis, Julie Holmes, Sarah Parry, Jane Stott, Tim Bolwell, Mark Chandler, David Harper and Mark Sarll.

INDEX